The Campus History Series

ALLEN COLLEGE

The Campus History Series

ALLEN COLLEGE

MARCEA K. SEIBLE

ARCADIA
PUBLISHING

Published by Arcadia Publishing
Charleston, South Carolina

Printed in the United States of America

Library of Congress Control Number: 2016939034

For all general information, please contact Arcadia Publishing:
Telephone 843-853-2070
Fax 843-853-0044
E-mail sales@arcadiapublishing.com
For customer service and orders:
Toll-Free 1-888-313-2665

Visit us on the Internet at www.arcadiapublishing.com

To my mother, Barbara Bramblett Seible,
Allen Memorial Hospital Lutheran School of Nursing
class of 1970.

CONTENTS

ACKNOWLEDGMENTS

This book would not have been possible without the support of many past and present Allen faculty, staff, and alumni. In particular, I would like to recognize the following individuals for their assistance: Dr. Jerry Durham, Dr. Jane Hasek, Dee Vandeventer, Dr. Joanna Ramsden-Meier, Rhonda Gilbert, Allison Jensen, and the members of the Allen Alumni Board. Special thanks also go to Liz Gurley, senior title manager at Arcadia Publishing.

Many of the pictures and much of the information in this book came from the letters, pictures, and memorabilia contained in the scrapbooks of Allen alumni and faculty. Special thanks go to Marcia Brandt, Dr. Brenda Barnes, Pat Buls, Joan Craig, Sue DeBower, Judith Eilers, Laurie Even, Janice Fitkin, Dr. Peggy Fortsch, Lola Galiher, JoAn Headington, Brenda Hempen, Mary Ann Howe, Kathy Janssen, Mary Kettman, Nancy Lamos, Connie Miller, Dr. Lee Nauss, Edith Oltman, Rosalie Richardson, Sue Robinson, Barb Seible, Julie Simbric, Carol Smith, Jean Stokes, Pat Warner, Dana Wedeking, Joan Wellman, Betty Wexter, Madeline Wood, Verona Zelle, and the many alumni who invited me to share in their memories over lunch. Also valuable were the images provided by the Allen Hospital Radiology Department, Carol Hansen of Carol Hansen Photography, and Larry Phillips of Cole Photography. Special thanks must also be given to Dr. Gerald Peterson for his advice and support throughout the duration of this project and to Dr. Janice Neuleib, whose friendship and mentorship encouraged me to pursue this project in the first place.

The Allen Family Reflections was regularly referenced in creating this book. The original work was compiled and edited by Leona Flynn, Robert Morrison, and Robert Neymeyer and published by the Allen Memorial Hospital Auxiliary in 1997.

Unless otherwise indicated, all images appear courtesy of Allen College.

INTRODUCTION

Allen College, with a proud history rooted in nursing education, has evolved into a regionally accredited, coeducational, specialized college enrolling more than 600 students in associate, baccalaureate, master's, and doctoral degree programs in nursing and health sciences. When Allen Memorial Hospital opened its doors in 1925, it simultaneously implemented its Training School for Nurses, which graduated almost 100 nurses before it closed in 1934, a victim of the Great Depression. The Allen Memorial Hospital Training School for Nurses was modeled after "diploma nursing" or "hospital nursing" which, in turn, emanated from the 19th-century Nightingale apprenticeship model of nurses' training. In this apprenticeship model, young women would work in hospital wards for three years under the supervision of experienced nurses and physicians in exchange for their education, room and board, and a small stipend. This model benefitted both the nursing student, who obtained vocational training, and the hospital, which received the student's services at minimal cost.

In the early 20th century, almost all nursing education transpired in hospitals and consisted of long hours of training in wards wherever the student nurse's services might be needed. Even as early as the 1920s, however, some critics of diploma nursing believed that the educational needs of nursing students and the service needs of hospitals were out of balance. Hospital-based training of nurses thrived until the 1950s, when a greater consensus arose around the idea that nurses needed a strong theoretical basis for their practice. By the 1960s, two-year associate degree programs began to take root in community colleges, and the American Nurses Association had issued a position paper in 1965 advocating university-based nursing education.

Allen Memorial Hospital's School of Nursing diploma program reopened in 1942 in response to the need for nurses in the US war efforts. It continued to graduate students from its three-year program for more than half a century until the Allen College of Nursing (Allen College today) graduated its first class of Bachelor of Science in Nursing (BSN) students. In the early 1980s, leaders of the School of Nursing, spearheaded by Dr. Jane Hasek, began to explore a possible change in its educational model. The options were to continue as a diploma program, to cease nursing education operations, to merge the nursing program into another post-secondary institution, or to become an independent, degree-granting institution. Allen leaders held discussions with leaders of several other post-secondary institutions, and at one point in these dialogues and planning efforts, it appeared that the school would become an academic unit of the University of Northern Iowa; however, when it became clear that the Iowa Board of Regents would not approve this plan, Allen leaders proceeded with a plan to establish the Allen College of Nursing. Because members of the Allen Health System Board were passionate about their support of the diploma program and their pride in its quality, they would not take action on its closure until Allen College was fully developed and accredited and had its first graduates. The board made the decision to admit the last class into the diploma program in the fall of 1994. This last diploma program class graduated in May 1997.

Allen College of Nursing was incorporated in 1989 as a subsidiary of the Allen Health System to offer degrees in nursing and allied health; the administrative structure was developed; and the BSN curriculum was designed with the assistance of consultant Dr. Sylvia Hart. Allen College of Nursing hired faculty and staff to meet the specific needs of the college. Once the diploma program ended, many faculty and staff went on to work for the college. During that time, Dr. Jane Hasek had two titles—vice president of Allen Hospital and chancellor of Allen College of Nursing—reflecting her dual responsibilities to both the diploma program

and the developing Allen College of Nursing. In 1990, the college gained the approval of the Iowa Board of Nursing to enroll its first class of students, who completed their BSN degrees in May 1994. In 1994, Dr. Kathy Schweer became the first full-time dean of academic affairs and held this position until her retirement in 2000. In 1995, Allen College of Nursing received regional accreditation by the Higher Learning Commission and has maintained this accreditation ever since. Also in 1995, Dr. Constantine Curris, president of the University of Northern Iowa, was awarded the first honorary degree from Allen College.

In the 1950s, Allen Memorial Hospital also sponsored a School of Radiology Technology and a School of Medical Laboratory Assistant/Technology certificate program. The Medical Laboratory Assistant/Technology program was discontinued in the 1980s due to low enrollment (possibly related to concerns about the HIV epidemic) and the implementation of a similar program at Hawkeye Institute of Technology (now Hawkeye Community College). Allen Memorial Hospital continued to collaborate with Hawkeye to give students clinical experience. The School of Radiology was a unit of Allen Memorial Hospital's Department of Radiology until the 1980s, when it was moved to the Department of Education. In 1995, Allen College of Nursing changed its name to Allen College (dropping "of Nursing") to signal its intent to offer health sciences programs in addition to those centered around nursing.

In 1996, Allen Memorial Hospital's radiography program was transferred to Allen College, and the last class of six students completed the hospital-based certificate program in radiologic technology. In 1999, the last class of nine students completed Allen College's radiography certificate program. After the college's radiography certificate program was phased out, four students graduated from the college's new Associate of Science in Radiography program in 2000. Following a hiatus of several years, Allen College reestablished a program in medical laboratory science in 2009.

Since 1995, the range of degrees offered by Allen College has increased along with the number of faculty and staff positions created in response to steady enrollment growth. By 2016, almost 40 percent of the college's students were enrolled in graduate-level study—most in one of the college's master's degree programs in nursing and occupational therapy. Still, for all of its growth and change, Allen College remains an Iowa-serving institution; more than 95 percent of its students come from Iowa, and most of the college's graduates remain in Iowa after graduation. Technology has had an enormous impact on the college's academic enterprise as evidenced by the number of courses and full degree programs now being offered through the use of distance education. The college is also increasingly diverse, with greater numbers of men and minority students. By August 2016, the college had operations in five buildings on the campus—Gerard Hall, Barrett Forum, Winter Hall, Alumni Hall, and McElroy Hall—all made possible through the generosity of individual donors, foundations, businesses, faculty and staff, and alumni.

Allen College's future looks promising. The college enrolls bright, energetic, goal-oriented students, employs caring and dedicated faculty and staff, and is supported by an engaged board of trustees and Allen Hospital leaders. The expanding need for a well-prepared healthcare workforce means that our graduates are in high demand. The college's well-deserved reputation of excellence will continue to attract students who seek careers in nursing and health sciences. As we go forward, we thank all who have had faith in and supported our mission to prepare exceptional healthcare professionals through educational programs of excellence; developing and sustaining a diverse community of learners, faculty, and staff; and promoting community service, scholarship, and lifelong learning.

—Dr. Jerry Durham
Chancellor, Allen College

One

A TRAINING SCHOOL
FOR NURSES

1925–1932

In the early 1920s, lawyer and businessman Henry B. Allen donated $200,000 and 80 acres of land at the northern edge of Waterloo, Iowa, to establish a hospital as a memorial to his wife, Mary C. Allen. A nursing shortage prompted the hospital to develop a school of nursing. In 1925, the completion of Allen Memorial Hospital and the Training School for Nurses, managed by the Deaconess Society of the Evangelical Church, created a new era of healthcare for the Cedar Valley.

Student nurses lived and worked in the hospital until 1931, when the nurses' residence was completed. With a capacity of 60, it provided living spaces, a solarium, a parlor, a kitchenette, laundry and sewing rooms, and areas for custodial and maid staff. The residence was furnished by local businesses James Black Dry Goods Co., Davidson's, and Nichols & Gates.

Five women were admitted to the first class under the direction of Gertrude E. Hof, principal and director of nursing from 1926 to 1934. Additional students joined in September 1926 to form the first graduating class of 10. According to a 1930 Allen School of Nursing manual, the three-year program admitted women between 18 and 35 years of age who were in good health, had completed 15 units of credit in an approved high school, and had received a letter of recommendation from their pastor and a family friend or employer.

As described in the manual, "All students must complete three full years and devote their whole time to their work and not permit outside interests to interfere in any way." Students did not pay tuition but were given a small amount of money as a monthly allowance. This sum was not considered a wage, since "educational training is given as compensation."

From 1925 to 1934, the school grew in students and space, and before it closed, it graduated 59 nurses. Economic trouble during the Depression resulted in fewer patients paying for hospital services, and the hospital went into the hands of receivers. In 1934, the nurses' training school closed, and the residence turned into a convalescent home to support the hospital's operation.

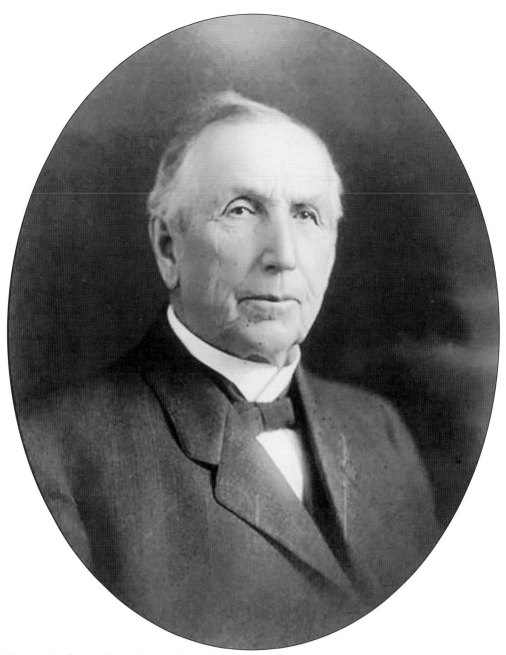

Henry B. Allen, a Waterloo resident, lawyer, and businessman, first saw Waterloo in 1855 and later made his home there in 1857. Allen had already passed away when Allen Memorial Hospital admitted its first patient and student nurse in February 1925.

After Henry B. Allen's wife, Mary C. Nowlin Allen, passed away, he donated $200,000 and 80 acres of land at the northern edge of Waterloo for the construction of Allen Memorial Hospital as a memorial to her. Waterloo architect Mortimer Cleveland designed the hospital, which included wards and private rooms as well as an ambulance entrance.

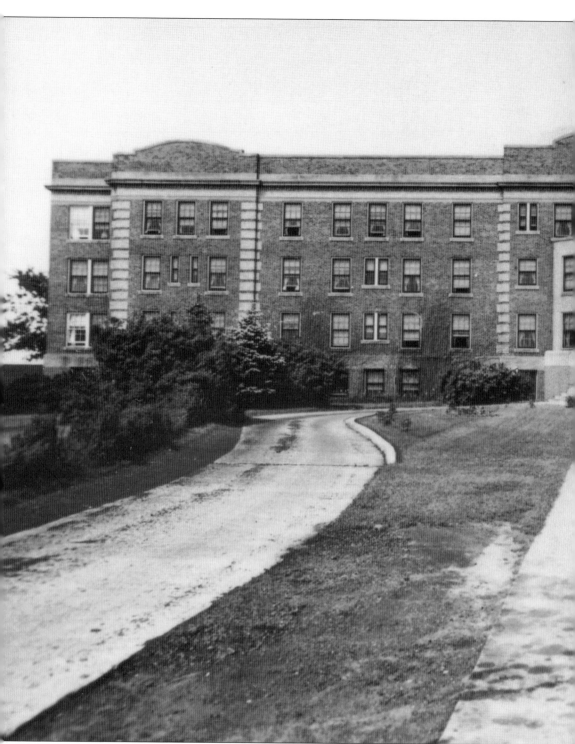

Officially located "at the end of Logan Avenue," the newly constructed Allen Memorial Hospital was far enough away from the city that it received no public transportation. Instead, patients were picked up at Franklin Street and transported the rest of the way in a hospital-owned

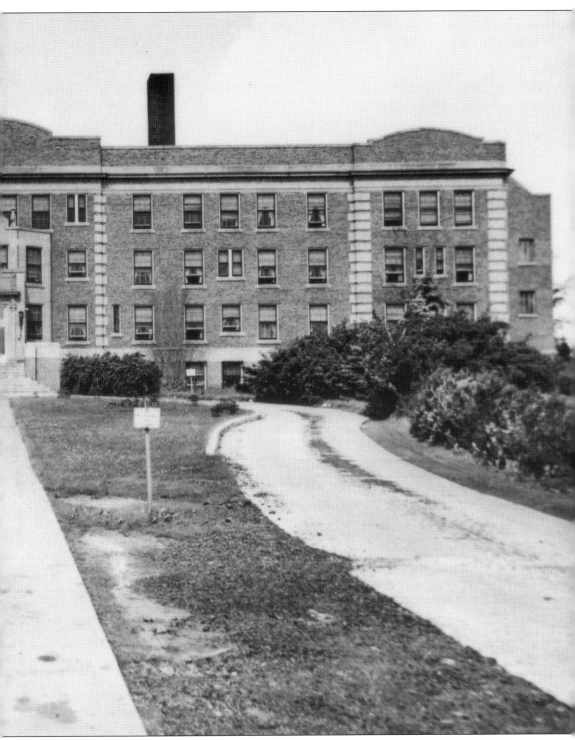

automobile. The hospital was designed to house 65 patients and a staff of 100, and contained space for medical, surgical, and obstetrical services.

After Henry B. Allen's death, his daughter, Dr. Harriet Allen Heath, and her husband, John E.S. Heath, donated $50,000 to finish the already-operating hospital. The *Waterloo Daily Courier* described the hospital as a notable accomplishment for the area: "The structure as a whole gives the impression of sturdiness of building, excellence of materials, refinement in construction, and conveniences not ordinarily found in hospitals." Though it was not the first hospital in Waterloo, it was considered one of the most impressive.

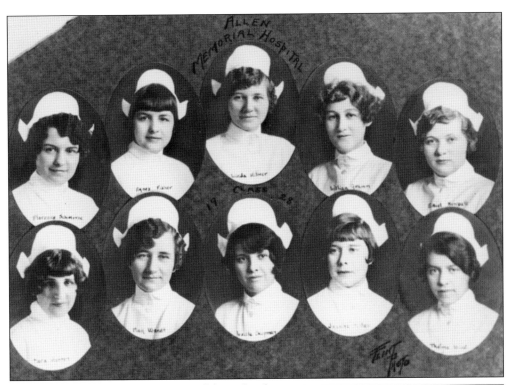

In 1928, the first graduating class of the School of Nursing contained 10 students. At that time, the hospital and school were operated by the Deaconness Society of the Evangelical Church. The original nursing cap was a folded men's handkerchief. Pictured here are, from left to right, (top row) Florence Schmerse, Agnes Fischer, Linda Hilmer, Lillian Gramm, and Ethel Kimball; (bottom row) Marie Janner, May Wendt, Lucille Chapman, Juanita Miller, and Thelma Wood. (Courtesy Flint Studio.)

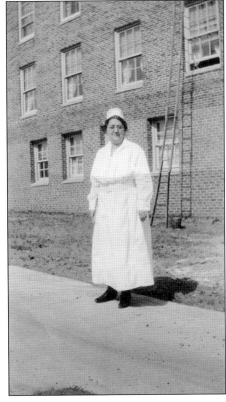

The School of Nursing was accredited by the Iowa Board of Nurse Examiners in April 1925. Its three-year course of study in nursing theory and practice was outlined by the National League for Nursing Education. Administrative staff played a critical role in the students' education in those early days. In this picture, Miss Bruns, superintendent of nurses, stands outside Allen Memorial Hospital.

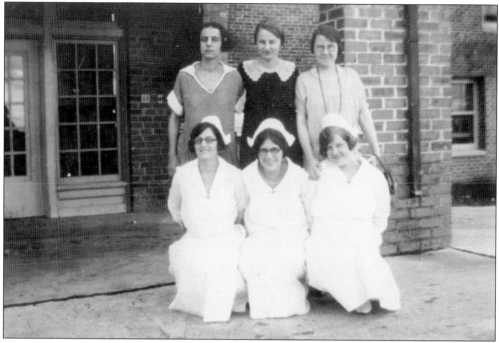

Above, Martha Wolf, surgical supervisor, is at center in the second row, while Willa Goetz, assistant principal and assistant superintendent, is on the far right in the first row. Below, in a more informal pose, Goetz (third from right) and Wolf (far right) are pictured outside the hospital. The others are unidentified but are likely nursing instructors given their white uniforms and lack of apron bibs. The Iowa license plate on the vehicle below indicates these pictures were taken in or after 1925.

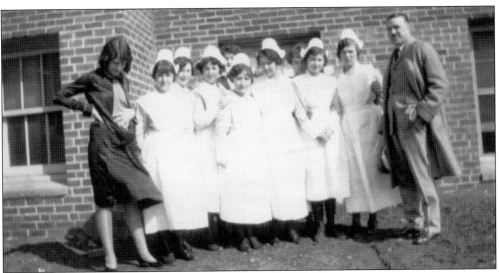

Students pose with unidentified administrative personnel in front of the hospital. The students include, in no particular order, Agnes Fischer, May Wendt, Linda Hilmer, and Ethyl Kimball, all members of the class of 1928. Their class yearbook provides insight to each of the girls' personalities. The caption for Agnes "Fish" Fischer's picture states, "No matter what the discussion, I always find room to disagree." May Wendt, aka "Wentie," is described as "Not very tall, in fact quite small, But fair and sweet, and loved by all." The caption for Linda Hilmer, aka "Lindy," reads, "Believe my words, for they are certain and infallible." Ethyl Kimball, or "Kim" to her classmates, was noted as saying, "He who invented eating was a great man."

Three unidentified students relax near the front door of the hospital in the late 1920s. Visible are their uniform apron bibs and black stockings and shoes. The 1928 class song, written by graduate Agnes Fischer, reflected on the important role the hospital played in students' nursing education: "And when we have gone out to the world/To nurse poor sick and suff'ring men,/We will oft look back to A.M.H.,/The place where we began."

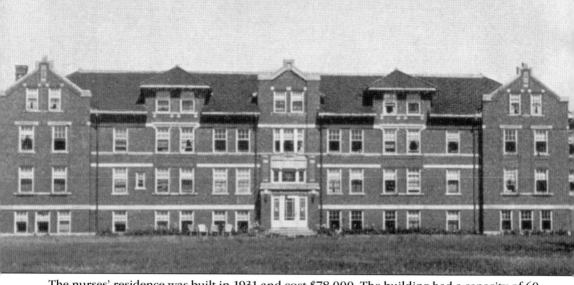

The nurses' residence was built in 1931 and cost $78,000. The building had a capacity of 60, and individual bedrooms for student nurses were located on the third and fourth floors, while graduate nurses lived on the second floor. The basement contained a kitchenette, dinette, laundry, sewing room, trunk room, school demonstration and recitation rooms, chemistry room, laboratory, auditorium, and library. It was connected to the hospital via an 87-foot covered walkway, making it easy for student nurses to travel between the two.

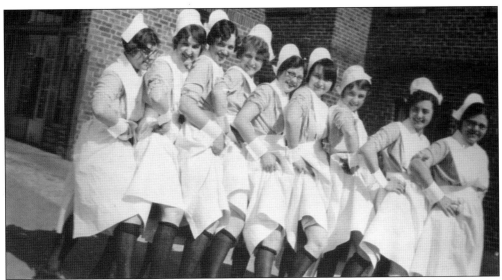

Students from the 1932 spring class enjoy a moment of levity following a day of clinicals. Gertrude E. Hoff, director of nursing from 1926 to 1934, designed the student uniform and cap. Before arriving at school, students were required to make three uniforms. They purchased six to nine yards of material and were given instructions for how to prepare them. Each uniform included a long-sleeved dress made of gingham that was 12 inches from the floor, a stiff white apron, black shoes, and black stockings. Students were also required to bring plain underwear, plain black oxfords with rubber heels, a laundry bag, scissors, a watch with a second hand, and a napkin ring. The hospital laundered students' uniforms, linens, underclothing, and handkerchiefs, but any other clothing had to be taken care of by students in the laundry room in the nurses' residence.

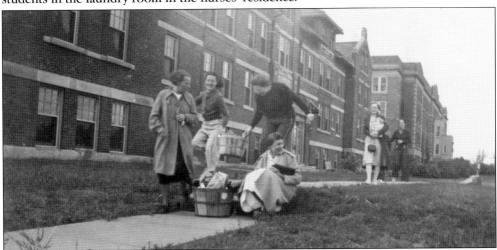

Though their nursing studies and work in the hospital demanded much time, students also managed to take part in recreational activities. May Wendt Fleming, graduate of the first class in 1928, recalled some of her non–nursing-related events, which included picnics at Gates Park in Waterloo and Casebeer Heights in Evansdale, gatherings in the sun parlor, Valentine's Day parties and Christmas programs, a watermelon party on the roof, and entertainment at the homes of Dr. Carl Bickley and Dr. W.H. Bickley. In this 1938 picture, students appear to be enjoying a summer day in front of the nurses' residence.

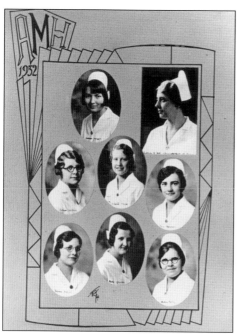

Eight students comprised the graduating class of 1932, as shown in the class picture taken by Flint Studio in Waterloo. A 1931 student handbook owned by Esther Laipple (pictured top left) describes how a student nurse was expected to live by a set of strict rules. Students were not allowed to wear their uniforms outside of the hospital zone and were forbidden to sit in automobiles and visit when in uniform. They were required to attend chapel services each morning from 6:30 to 6:45 a.m. and on Thursday evenings unless they were on duty. Students found guilty of smoking or drinking "intoxicating liquor" and/or "keeping company with individuals of questionable character" would be dismissed. Any student who married while in training was automatically expelled from the school.

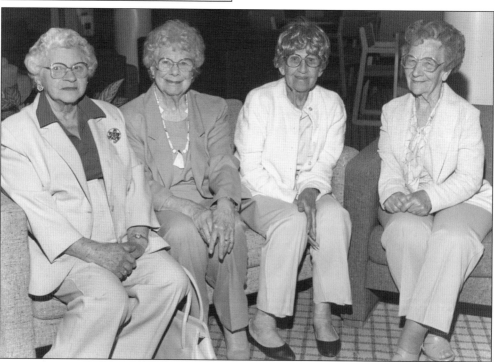

Alumni banquets are a special occasion when former Allen students can reminisce about the "good ol' days." In 1988, four women from the first graduating class of 1928 were honored as 60-year graduates of the School of Nursing. The women in this photograph symbolized the first of many student nurses to graduate from Allen. Their achievements continue to be recognized by those who have come after them. From left to right are Linda Hilmer, Juanita Miller Lininger, Marie Janner Shapiro, and May Wendt Fleming.

Two

ALLEN MEMORIAL HOSPITAL LUTHERAN SCHOOL OF NURSING

1942–1997

After the nursing school closed in 1934, Allen Hospital continued to serve patients but struggled to remain open. In 1938, management of the hospital was turned over to the Lutheran Good Samaritan Society, which assumed the hospital's debt and created a new governing board. These changes allowed the nursing school to reopen in 1942 with a new name, the Allen Memorial Hospital Lutheran School of Nursing, and a new director of nursing, Sadie Holm. When the school reopened during World War II, the students were a part of the Cadet Corps and wore military uniforms. Virginia C. Turner succeeded Holm as the director of the School of Nursing and served in that position from 1957 until 1979. Dr. Jane Hasek was director of the school from 1980 to 1997.

Students' educational opportunities grew as the school formed partnerships with Iowa State Teachers College (ISTC), now the University of Northern Iowa, in Cedar Falls; Cook County Hospital in Chicago; and the Mental Health Institute (MHI) in Independence. First-year students took classes in biological, physical, and social sciences at ISTC. In their junior and senior years, they received instruction and clinical experience in medical-surgical nursing, maternal-child nursing, psychiatric nursing, and community health.

Female students were required to live in the nurses' residence until the late 1960s and could not be married until the end of their senior year or after graduating. They were expected to follow strict rules regarding study hours, curfews, and visitors. Time spent in close quarters with peers resulted in significant bonding experiences, a tradition that changed as more students chose to live off campus in the 1970s and later. In addition to their studies, students participated in various extracurricular activities on campus. The completion of Dack Hall in 1958 provided additional classroom, recreation, and living space.

In 1998, "Lutheran" was removed from the school's name, and the school became the Allen Memorial Hospital School of Nursing. The diploma program continued until 1997, when the last class graduated, effectively ending an era of hospital-based diploma education that lasted for almost 60 years.

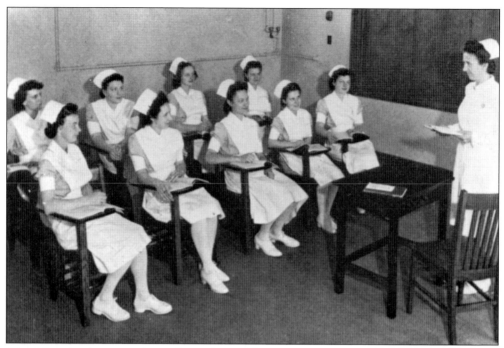

When the school reopened in 1942, student uniforms had changed. The uniform now included a short-sleeved dress with white cuffs, white hose, and white shoes. Unlike the early days, when students had to make their uniforms and bring them to school, post-1942 students received their uniforms (minus the cap) shortly after arriving. Students wore uniforms similar to these until the late 1960s.

Students wore nursing caps like this one from 1942 through the end of the diploma program. This cap was designed by Sadie Holm, the first director of the Allen Memorial Hospital Lutheran School of Nursing. Many students remember it as challenging to fold. It returned from the laundry as a piece of stiff, starched, flat fabric. An upper-class student was usually consulted to help identify where folds should be made and pins inserted to create the shape seen here. A loop was inside what became the top front of the cap. A small comb or bobby pin was used to secure the cap in the student's hair, and white bobby pins were used in the back corners. (Courtesy Barb Seible.)

The shortage of nurses and the need for those qualified to work during World War II led the United States government to begin the US Nursing Cadet Corps. Allen was granted permission to participate in January 1944 and took on an additional class of 13 students. Tuition and fees were paid and students were provided uniforms, room and board, and a monthly stipend. In return, students agreed to engage in essential nursing throughout the war. Here, Betty Atkins (class of 1948) shows her uniform as part of the Cadet Corps at Allen.

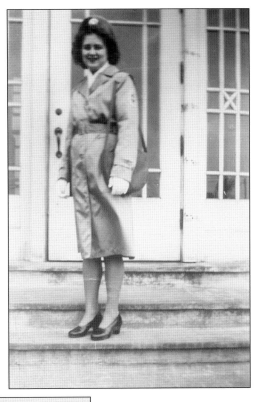

LUTHERAN SCHOOL OF NURSING

ALLEN MEMORIAL HOSPITAL, WATERLOO, IOWA

OFFICE OF
DIRECTOR

May 4, 1954

Miss Judith D Heerts
Holland, Iowa

Dear Miss Heerts:

I am pleased to inform you that the Nursing School Committee has formally accepted you as a student for our fall class.

You may begin your immunization series anytime now. Use the enclosed form and return it upon its completion.

Thursday, July 29th will be G. A. Day (Get Acquainted Day). At this time your uniform measurements will be taken and our routine physicals will be given.

Registration shall be on September 13, 1954, complete details will follow. In order to insure a place in this September class, I would ask that the $5.00 matriculation fee be paid immediately. This should be in the form of a check or money order payable to the Allen Memorial Lutheran School of Nursing. This is not returnable.

I shall be glad to be of any further assistance and again my congratulations.

Sincerely yours,

Edna Snavely

Edna Snavely, R. N.
Director of Nurses

ES/pw

After submitting their admission materials, applicants to the Allen Memorial Hospital Lutheran School of Nursing would receive a letter inviting them for an interview with an administrator or faculty member, which often occurred before the student was officially accepted. As indicated in this acceptance letter that followed Judith Heerts's interview, students were then required to get immunizations before attending and would receive a "routine physical" exam upon arrival. Acceptance in the program led to three years of studying and learning. (Courtesy Judith Eilers.)

Verona Orth arrived at Allen in the fall of 1949. In her acceptance letter, Hedvig A. Fredan, RN, director of nurses at Allen from 1949 to 1951, wrote, "I hope that you will realize the serious responsibilities you will have as you enter the nursing profession. We need nurses who not only are good students scholastically but are also of the right spirit. It will be our aim to give you the education and experience so that you will be prepared to practice as a professional nurse and to be the kind of nurse who will be a credit to her profession and school and still have the ability and capacity to enjoy a good life." (Courtesy Verona Zelle.)

This 1968 picture by Wente Photography, based in Waterloo, shows the large murals on the east side of Dack Hall. The murals were commissioned by Mr. and Mrs. John W. Dack in 1957 to reflect the spirit of nursing and were designed by Gerald N. Shirley. Completed in 1958, they were composed of more than 1,400 hand-fired six-inch ceramic tiles. This part of the Allen Memorial Hospital Lutheran School of Nursing faced Logan Avenue/Highway 63 and was often a visitor's first glimpse of the hospital and school. Over the years, it became a well-recognized part of the School of Nursing.

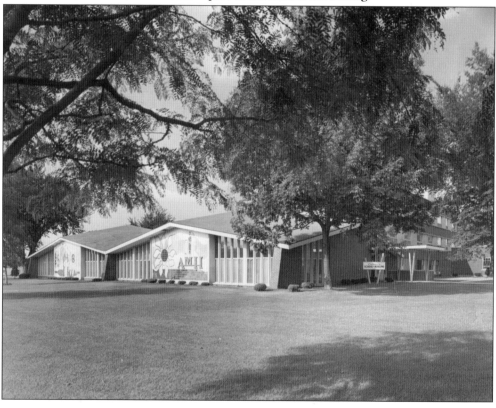

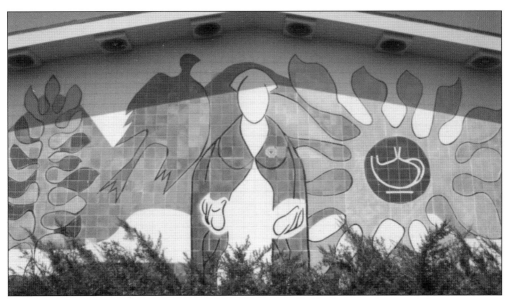

Pictured in this mural are items symbolizing the life and work of Allen student nurses. The focal point of the mural is a graduate nurse wearing a blue cape with the Allen school pin. Her arms are opened to welcome the sick. Surrounding her are a tree, a dove, the sun, and the Florence Nightingale lamp, all meant to symbolize the dreams of a student nurse. The tree of knowledge represents the seed once planted that continues to grow. It also represents the hard work and sacrifices of those who share their knowledge with others who are willing to serve. The dove represents the free spirit of nursing and the activities of the student nurse meant to keep her strong in both body and mind. The sun nurtures the seed and the dove and, together with the lamp, shows the promise of expansion and new horizons.

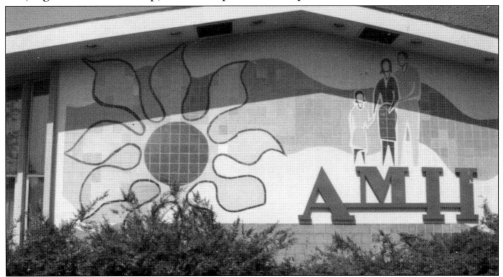

This mural represents the school's working partnership with Allen Memorial Hospital. Featuring the hospital's abbreviated name ("AMH"), the sun, and a family, it shows the hospital's role in providing care for the communities it serves. Here, too, the sun represents service and duty to those in need and the continual developments in medicine and nursing. Together, the two murals represent the close partnership between the school and the hospital.

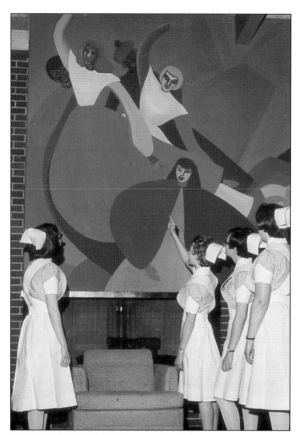

This mural, which expresses the caring work of nurses, was located over the fireplace in the Dack Hall student lounge and was a familiar sight for student nurses and faculty from the late 1950s to the early 1980s. It was painted by Waterloo-born artist Jessie Loomis, whose husband, Dr. Frederick Loomis, was a physician at Allen Memorial Hospital. Jessie Loomis, who was an art teacher at Dunkerton School, was considered one of the best watercolor artists in Iowa.

When students received their nursing caps, they were recognized as having completed a portion of their nursing education. It was a very special event signifying accomplishments, survival, and pride in their education. In this picture from the 1940s, director of nursing Sadie Holm (standing just left of center) adjusts an unidentified student's cap as part of a capping ceremony.

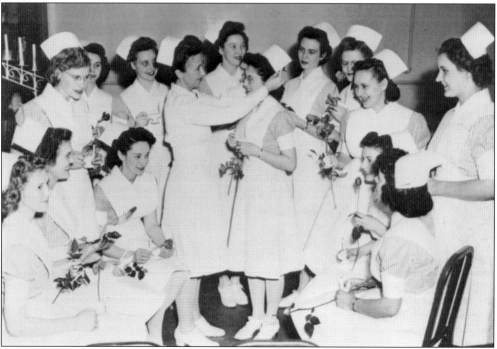

For many years, capping ceremonies were formal school events attended by students' family and friends. Cards such as this one honored students for their achievement and were widely available and often given to recognize students' achievements. In later years, ceremonies became less formal, yet the cap remained symbolic of a nurse's education and entry into the profession. (Courtesy Rosalie Richardson.)

In this 1950s photograph, three students try on their newly-received nursing caps and are concerned with how to secure the cap on their heads. It took a little practice to know exactly how to secure the cap. Some folded a tissue to give it some bulk with their hair when trying to hold it in place with bobby pins. Some used a small comb if their hair was especially thick. (Courtesy Judith Eilers.)

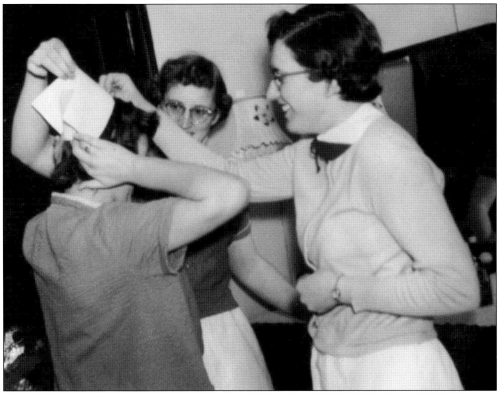

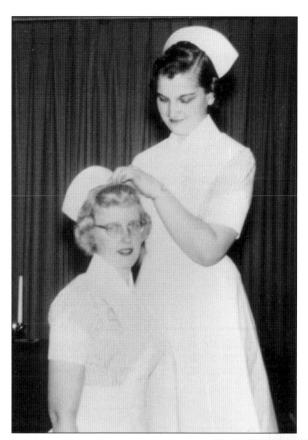

Students received their caps in different ways. Some were capped by the director of nursing, while others were capped by their "big sisters"—upperclassmen who provided support for the freshmen. Here, Judith Heerts kneels while being capped by her big sister, Helen Kubicek, in a capping ceremony during the 1950s. Each year, new students were assigned a big sister who served as a mentor, offering encouragement and advice about nursing classes and student life. (Courtesy Judith Eilers.)

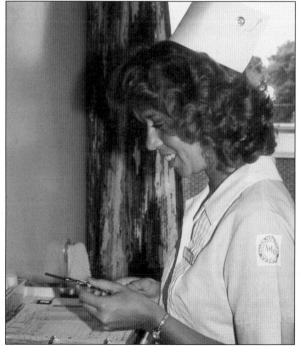

The nursing cap was an important part of a student's uniform. Allen students wore the same cap, but each had her own class pin. This small pin, which was different from the school pin, was selected by the class, and some included a small chain connecting it to the year the student would graduate. Nurses could recognize where and when another nurse attended school by looking at each other's caps. The pin and chain are visible in this picture from the early 1970s.

Preparing the uniform was part of a student nurse's evening routine. Students were required to keep their shoes white and the shoelaces clean. Some instructors were particularly picky and might even lower a student's grade if her shoes were not completely white. Thus, preparations for clinical always included special attention to one's shoes. Patricia McMullen (left) and Madeline Armstrong are shown in their dorm room preparing their shoes for inspection in the mid-1950s. (Courtesy Madeline Wood.)

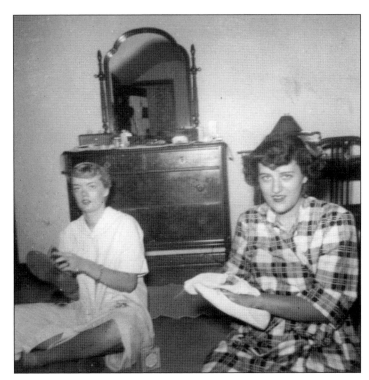

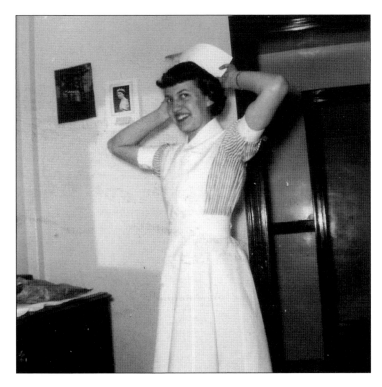

Student Kathy deNeui (class of 1955) adjusts her cap while dressing in the dormitories. Students' heavily starched bibs and aprons rustled loudly enough to announce when a student was approaching. Uniforms were laundered at the hospital laundry and returned to a room in the dorms where students would pick out each part of their uniform. Students' names were sewn into the separate parts of the uniform, including inside the dress and on the bib. (Courtesy Madeline Wood.)

29

Because the hospital laundered student uniforms, students were often required to sew their names inside each article for identification. Students received name strips like the one shown here, cut them into pieces, and sewed them on each part of the uniform. Students' memories about how they received their clean laundry differed. Some recall it being left on their beds, while others remember picking it up from a room in the basement. (Courtesy Mary Ann Howe.)

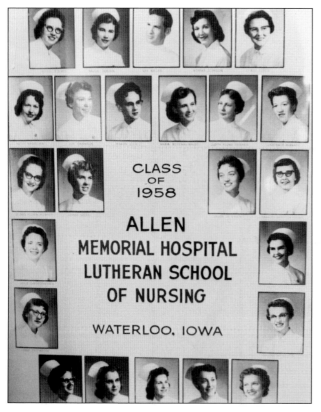

CLASS OF 1958

ALLEN MEMORIAL HOSPITAL LUTHERAN SCHOOL OF NURSING

WATERLOO, IOWA

Lee Nauss (top row, center) was the first male student to attend and graduate from the Allen Memorial Hospital Lutheran School of Nursing. As a result of his acceptance, the school had to make special accommodations, including creating a separate space for him to study apart from the female students. He was not allowed to live in the nurses' residence and so rented a room a short distance from the hospital. Madelyn Melchert, the housemother, would check on him while he was studying and ensure he left campus by 10:00 p.m. He and Maria Rosenau (second row, third from right), who was also a student at Allen, were married shortly after their graduation in 1958. Flint Studio in Waterloo took professional pictures of students at the School of Nursing for many years.

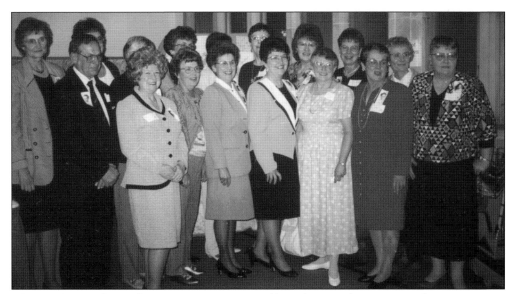

After graduating from Allen, Lee Nauss continued his education by training to become a nurse anesthetist at the Mayo Clinic in Rochester, Minnesota, and earned his Certified Registered Nurse Anesthetist (CRNA) certification in 1960. After a few years practicing in Alaska, he attended medical school at the University of Arkansas in Little Rock, graduated in 1971, and then, after an anesthesia residency at Virginia Mason Hospital in Seattle, joined the Mayo staff in 1974 as an anesthesiologist. He was instrumental in developing the prominent pain clinic at Mayo. In 2008, he was inducted into Allen College's Distinguished Alumni Hall of Fame for his achievements, contributions to healthcare, and support for nursing and healthcare education. This picture shows Nauss (first row, far left); his wife, Maria (first row, second from left); and other members of the class of 1958 at their 50th reunion in the Dack Hall gymnasium.

During the 1950s and early 1960s, Allen students rode a bus to attend classes at Iowa State Teachers College (ISTC) in Cedar Falls. The school made arrangements for the bus to pick up students, take them to ISTC, and return them to Allen later in the day. The school also provided a sack lunch, which one student remembered containing either a braunschweiger (sausage) or a peanut-butter sandwich. This picture shows students boarding the bus in the 1960s.

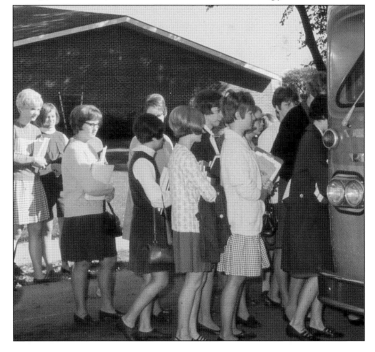

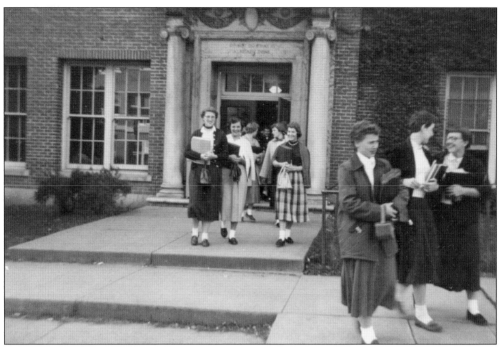

In their first year, students at Allen took courses in anatomy and physiology, chemistry, and microbiology at ISTC. The above photograph shows Allen students walking in front of well-known buildings on campus, including Wright Hall and the laboratory, aka the physics building. Below, Allen students Kathy deNeui (foreground) and Madeline Armstrong are dissecting pigs in their anatomy class. Allen students often joked that everyone on the ISTC campus knew who the Allen students were because they smelled like formaldehyde from their anatomy classes. (Above, courtesy Judith Eilers; below, courtesy Kathy Janssen.)

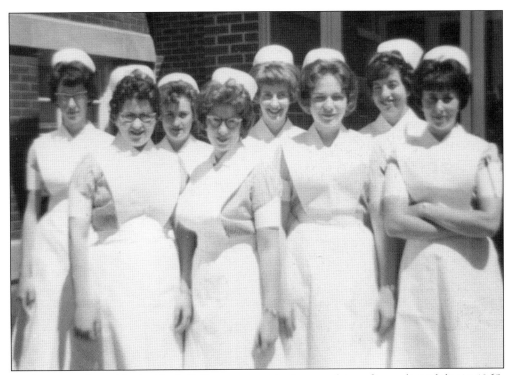

Students stand outside the Dack Hall entrance enjoying sunshine after a clinical day in 1965. Students were put into rotation groups that moved through their clinical experiences together. From left to right are (first row) Sheryl Torkelson, Sherry McChesney, Connie Christensen, and Mildred McCallum; (second row) Marcia Brandt, Barb Bramblett, Paulette Seeghers, and Renee Schmidt. (Courtesy Marcia Brandt.)

Smaller nursing schools, like Allen, were often affiliated with larger schools and hospitals, providing an opportunity for more complete training. As part of their program, Allen student nurses took classes and worked at the Cook County Hospital in Chicago. While there, they spent time with patients in psychiatry (now called mental health) and pediatrics. Later, students affiliated to the Mental Health Institute (MHI) in Independence, Iowa. Pictured here in 1954 is the Cook County Nurses' Residence, where Allen students lived during their time in Chicago. (Courtesy Kathy Janssen.)

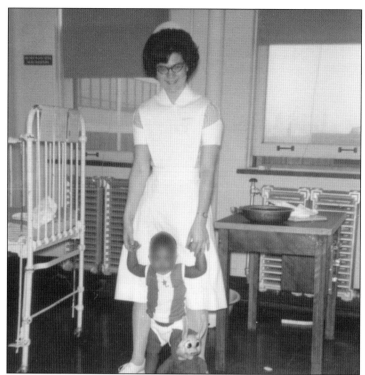

Class of 1967 student Mary Ann Bucholtz walks with a child during her pediatrics rotation in Chicago. Her group of students spent four months at Allen Hospital, four months at Cook County Hospital in Chicago (for pediatrics), and four months at MHI in Independence. This Allen class was the last to complete a rotation at Cook County Hospital. Afterward, students completed rotations in obstetrics and pediatrics at Allen and other local hospitals. (Courtesy Mary Ann Howe.)

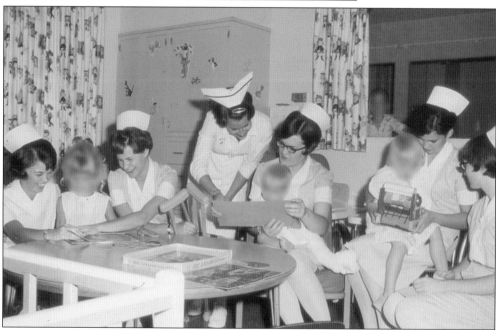

Instructor Pam Sipes (center, standing) works with a student group in the Allen Hospital pediatrics unit in the late 1960s. Student nurses spent time with children in the playroom as part of their clinical rotation. Each student was assigned a patient to care for and study. During students' post-conference meetings, they discussed each child's unique health problems and learned about different diagnoses.

34

After pediatrics rotations at Chicago's Cook County Hospital ended in the late 1960s, students had their obstetrics and pediatrics experiences at Allen Memorial Hospital and nearby St. Francis Hospital, now Wheaton Franciscan Healthcare. At right, Joan Craig and Deb Dunn care for an infant in an Isolette at St. Francis Hospital. Below, students are pictured during a rotation to Blank Children's Hospital in Des Moines in the early 2000s. There, they experienced working with children who had a variety of medical conditions. From left to right are students Kimberly Helgeson, Emily Fischer, Kallie DeWall, Larry Bathen, Amber Luchtenberg, Laura Straube, and Susan Willemssen. (Right, courtesy Joan Craig.)

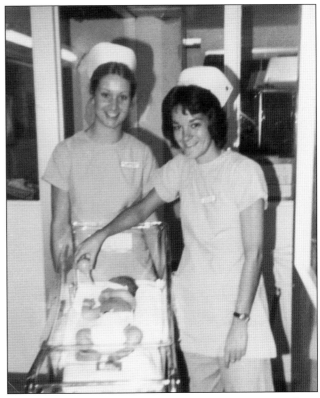

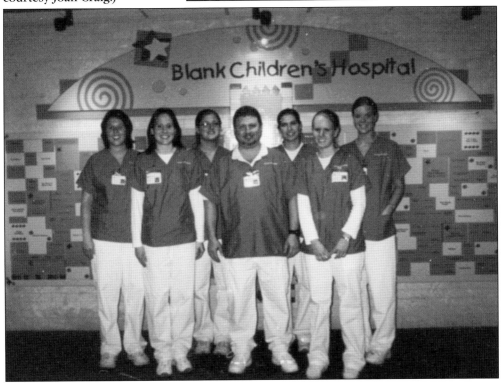

The Mental Health Institute opened in Independence in 1873 as the Iowa Hospital for the Insane and was later known as The State Hospital. Modeled on the Kirkbride plan, the building was situated on spacious lawns and provided a sanctuary-like atmosphere for patients. MHI residents, many of whom lived at the facility for many years, often worked on the grounds, which included large lawns, flower beds, gardens, and barns. (Courtesy Janice Fitkin.)

A large building on the MHI campus provided dormitory space for students during their mental health classes and clinicals. Later, students were allowed to commute to MHI but were given a dormitory room to complete paperwork on campus. While at MHI, Allen students met students from different schools of nursing who were identified by their different uniforms, caps, and school pins. (Courtesy Mary Ann Howe.)

"Going to Indy" was a familiar way for students to describe their mental health rotations at MHI. These rotations usually lasted between eight and twelve weeks. Pictured here is a group of Allen students sitting in the lounge during their MHI rotation in the mid-1950s. (Courtesy Rosalie Richarson.)

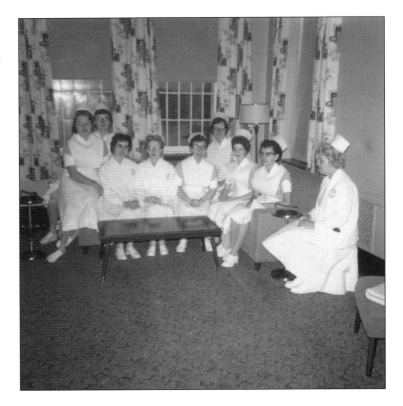

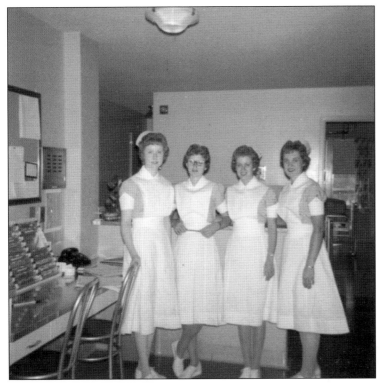

Students in clinical rotations were easy to recognize because of their uniform, which included a blue-and-white pinstriped dress; a white bib, apron, cuffs, and collar; white nylons and shoes; and watches with a second hand. In this 1950s picture, students wait at the nurses' station, where they would give reports to other nurses and write in patients' charts, which are visible at left in the hanging file. (Courtesy Brenda Hempen.)

Students preparing for clinicals in 1980 needed to adhere to certain guidelines. Their hair had to be worn off their collar, and uniforms had to be clean and crisp. Students had to have a watch, white shoes, their nursing cap (which traveled in a cap bag or ice cream bucket, both seen here), scissors, and a stethoscope. It was typical for students to bring a clipboard and pen. Faculty assigned patients to each student for clinicals, yet students took reports on all patients in case they needed to answer a call light for one of them. (Courtesy Joan Craig.)

Janeen Weigel, a 1990 diploma program graduate, sits at a typical nurses' station at Allen Hospital. She is transferring information about a patient from her clipboard to the patient's paper chart. In the chart, she will identify hour-by-hour care her patient will need while she is working this shift and will organize her day using this information. She is wearing the student uniform of the time, which included a white shirt and pants, a pale-blue pinstriped tunic, and a lab coat with the Allen School of Nursing emblem.

Diploma nursing student Renee Chester (class of 1992) thumbs through the Kardex during her clinical. One page in this file provides a wealth of information about a patient, including name, doctors, diagnosis, treatments, procedures, activity orders, IV orders, and much more. The student will then continue to update this information as needed.

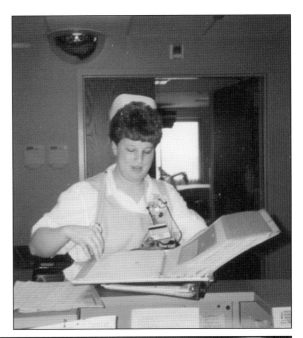

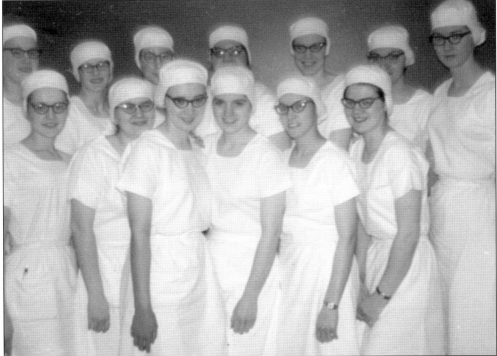

In addition to pediatrics, obstetrics, and mental health rotations, students also completed medical-surgical rotations and spent time in the operating room. This picture shows students from group 3 of the class of 1968 during their operating room rotation. They wore white cotton dresses and cloth caps, both of which were essential in controlling static electricity in the operating room; this was important during the administration of anesthetic gases. Wearing shoes with copper pegs in the soles was another preventive measure. (Courtesy Marcia Brandt.)

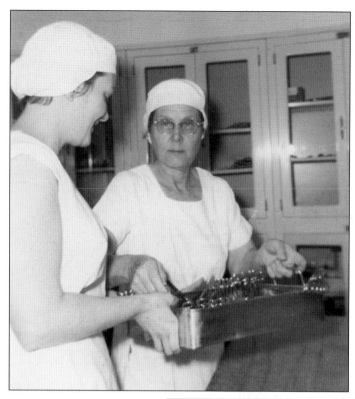

The student pictured at left in this 1950s photograph is learning how to prepare instruments for cases. Part of the obstetrics and operating room rotation included learning about instruments—their names, how to anticipate which one might be needed, and how to properly hand them to the surgeon. (Courtesy Lola Galiher.)

In this April 1981 role-play, students in a medical-surgical clinical back into the operating room after scrubbing. They will put on gowns and gloves in the operating room. Students in the perioperative nursing rotation learned basic sterilization techniques, instrument names, how to safely position patients, and how to circulate within the operating room. Students were actively involved as team members during surgical cases. By this time, student uniforms for the operating room had changed; they wore colored scrub sets, paper caps, and shoe covers. (Courtesy Barb Seible.)

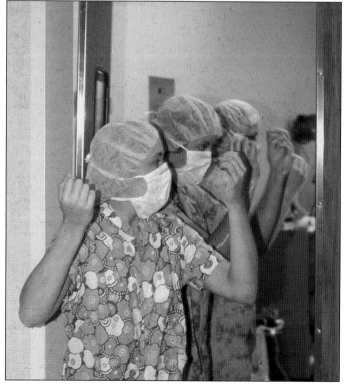

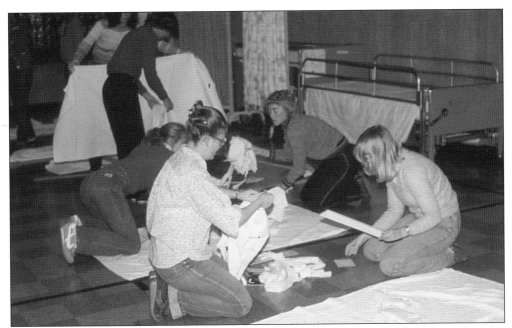

Classrooms at the school provided different types of instructional spaces for students. In this 1980s picture, students in the gymnasium in Dack Hall practice basic first-aid skills by preparing bandages. Students took turns lying on the ground and practiced applying dressings by wrapping hands, fingers, and ankles. Beds were used for learning how to position and transfer patients, give baths, apply TED hose, and assist patients with bedpans.

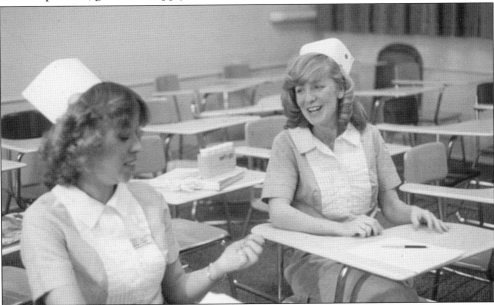

Two unidentified students enjoy a lighter moment after returning to class following their clinical experiences in the 1970s. From the 1940s to the 1960s, the student dress code evolved to include one-piece and two-piece uniforms. Students could still wear dresses, but they could also wear uniforms comprised of shirts and pants. This classroom was in the basement of the original School of Nursing building.

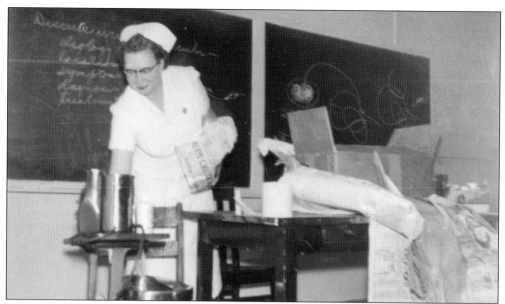

Starting in 1953, Virginia C. Turner was the Fundamentals of Nursing instructor for the Allen Memorial Hospital Lutheran School of Nursing. "Miss Turner," as she was known to her students, kept classes interesting with her stories of personal experiences in nursing. She told these in a professional manner with an application to what her students were learning. She served as the director of the School of Nursing from 1957 until 1979. In 1964, she was appointed to the Iowa Board of Nursing and served until 1973. (Courtesy Nancy Lamos.)

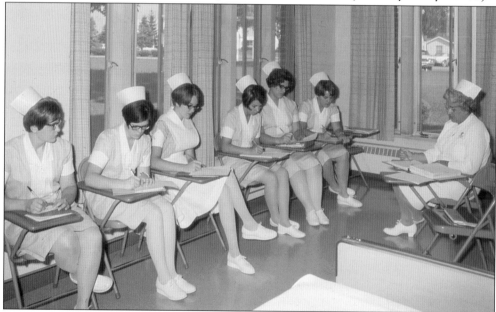

Lucille (Tubesing) Carolan (far right), faculty and Allen class of 1945 graduate, meets with students following a busy clinical day in 1967. Here, students reviewed the day's experiences with each other in a "post-conference" setting. Note that the student third from left is wearing a different uniform from the others; this indicates that students from different years' classes may have rotated to clinical sites together.

On the students' final day of clinicals before graduating, doctors, nurses, and other student nurses signed each other's uniforms. In this photograph, Virginia C. Turner (left), director of the School of Nursing, signs student Janet Timmons's uniform in 1962. (Courtesy Janet Larsen.)

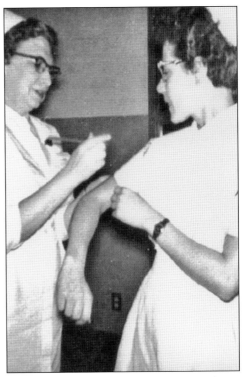

This uniform bib from Mary Ann Bucholtz's last clinical day in 1967 includes notes wishing her good luck as well as signatures from well-known Allen Hospital doctors including Russell S. Gerard II, Howard Hartman, Ross Randall, J.A. Jeffries, Cecil Seibert, F.H. Entz, Andrew Smith, John Moes, Ed Sitz, Rolf Kruse, Robert Bailey, R.E. Morrison, and Louis Zager. (Courtesy Mary Ann Howe.)

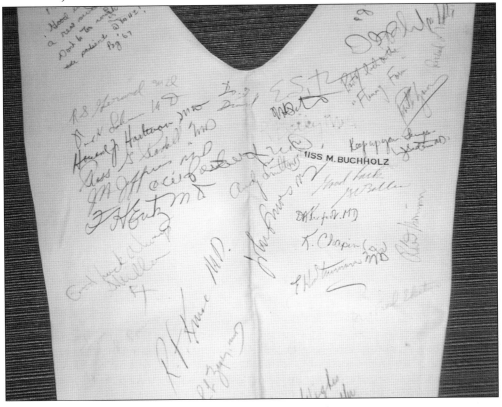

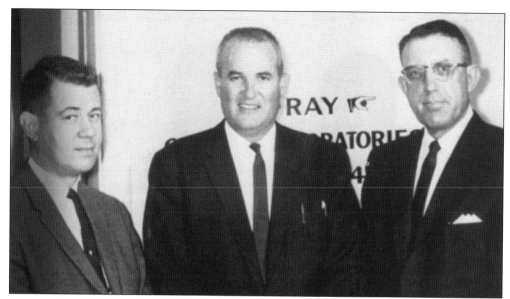

Allen Memorial Hospital medical staff also taught classes and provided special lectures for students at the School of Nursing. Students working in the hospital were assigned to care for patients and worked closely with physicians in the clinical units. Pictured here in the 1950s are, from left to right, Dr. Rolf Kruse, urology; Dr. Russell S. Gerard II, medical and surgical; and Dr. Cecil W. Seibert, obstetrics and gynecology.

Students scrubbed in and worked alongside doctors and nurses during various surgical cases. Dr. Arthur Devine, Allen Hospital general surgeon, contributed to the education of many Allen students during their operating room rotations. His calm and patient demeanor put many nervous students at ease when they were learning about the role and responsibilities of the operating room nurse. Pictured here are, from left to right, (first row) Geri Meyerhoff, Dr. Devine, and Margaret Buenger; (second row) Nancy Lamos, Beth Bryant, Pasty Ott-Pick, Ruth Thomas, and Deb Secor. Often, Allen students who had rotations in the operating room as part of their education sought positions there after graduating—Lamos, Bryant, Meyerhoff, Ott-Pick, and Buenger are Allen graduates who later worked in the operating room at Allen Hospital. (Courtesy Nancy Lamos.)

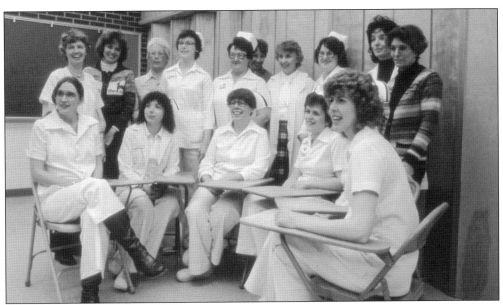

School of Nursing faculty wore their uniforms when teaching students during clinical rotations. This picture from the mid-1970s or early 1980s was taken in a classroom in Dack Hall. Faculty had meetings once a week to discuss curriculum and other instructional matters. From left to right are (first row) Jean Stoddard, Jo Heth, Sharon Graber, Barb Braband, and Jo Graham; (second row) Jan Donlea, Mary Brown, Nancy Muntzing, Judy Roberts, Darlene Shipp, Jo Fernau, Cecelia (Ramsey) Shaw, Barbara Seible, Marianne Reynolds, and Sheila Dark.

Laurie Finley, a student in her medical surgical classes during her junior year, scrubs in as part of the surgical team during her operating room rotation in the early 1980s. Note the name tape across the top of her head. By wearing this, Finley was identified as one of the students of perioperative instructor Barb Seible. This helped staff welcome students to the operating room and gave them the proper spelling of the student's name for the records. It was also a way for Allen students to say, "Teach me; I'm here to learn." Operating room staff knew that students who wore the name tape had learned basic operating room theory and were there to interact with staff and apply their knowledge. (Courtesy Laurie Even.)

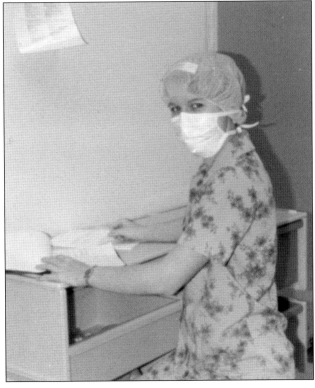

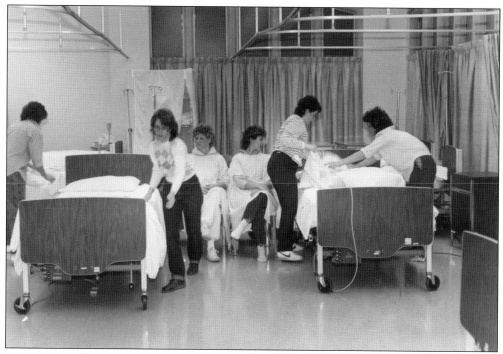

Room 104, built in 1962 as part of the second addition to the Allen Memorial Hospital Lutheran School of Nursing, provided additional classroom and lab space. In this fundamentals of nursing class, students demonstrate to faculty their skills such as making beds, giving baths, applying dressings, and positioning and transferring patients. This room included medical equipment and beds meant to model a hospital environment.

Students took classes in basic nursing skills, including laboratory sessions. One lab rule required students to remove shoes if they would be on the patient beds. Here, diploma student Nicholas Graff is getting ready for a lab experience in the Dack Hall laboratory classroom, room 104.

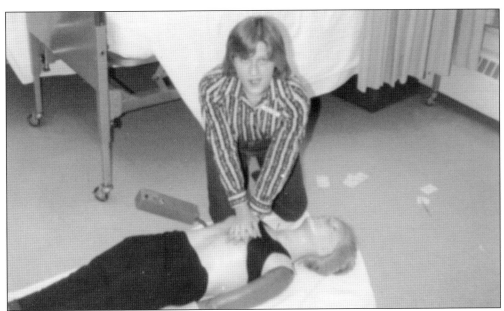

Each class at Allen received instruction in Basic Life Support (BLS). Many hours went into memorizing and practicing BLS skills. Faculty taught some classes, and the Allen Student Nurses Association (ASNA) also taught classes as a fundraiser. Students took a written exam and demonstrated infant, pediatric, and adult BLS for an instructor. In later years, students could also come to the college with CPR certifications already completed. In this picture, student Laurie Finley is practicing CPR on a practice patient. (Courtesy Laurie Even.)

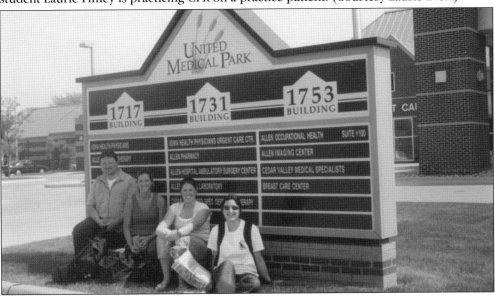

From left to right, Larry Bathen, Elizabeth Trees, Kimberly Helgeson, and Jennifer Peterschmidt pose outside the United Medical Park on Ridgeway Avenue in Waterloo. These BSN students were part of Barb Seible's perioperative class in the early 2000s. Building 1731 housed the Ambulatory Surgery Center, where students completed one of their clinical experiences. During their post-surgery conferences, students compared outpatient versus inpatient surgeries. (Courtesy Barb Seible.)

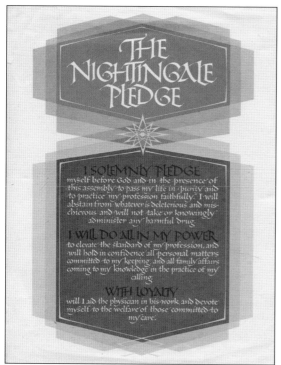

THE NIGHTINGALE PLEDGE

I SOLEMNLY PLEDGE myself before God and in the presence of this assembly to pass my life in purity and to practice my profession faithfully. I will abstain from whatever is deleterious and mischievous and will not take or knowingly administer any harmful drug.

I WILL DO ALL IN MY POWER to elevate the standard of my profession, and will hold in confidence all personal matters committed to my keeping, and all family affairs coming to my knowledge in the practice of my calling.

WITH LOYALTY will I aid the physician in his work and devote myself to the welfare of those committed to my care.

When classes were done, clinicals completed, and tests taken, students readied themselves for graduation. The Florence Nightingale Pledge was an important part of each graduation ceremony. With the room darkened, each graduate lit her small Nightingale lamp from a large gold lamp and recited the pledge that expressed their commitment to the nursing profession. When the diploma program ended, the lamp and recitation of the pledge were no longer included as part of the graduation ceremony.

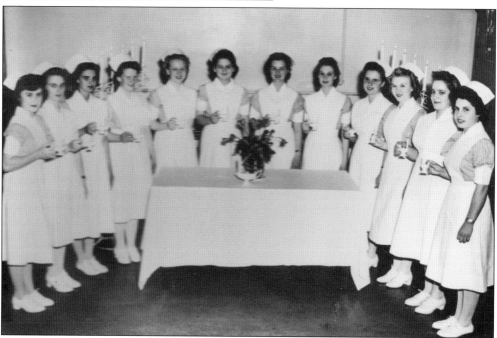

Students of the February class of 1948 are holding their Florence Nightingale lamps, with each candle lit, and wearing their student uniforms during their capping ceremony. From left to right are Margaret Garner, Gwen Moorhead, Ellen Goarke, Ethyl Sage, Helen Peterson, Betty Atkins, Janice Kracht, Fern Wilson, Marion McDonald, Elsie Wilson, Norma Wolfe, and Erma Knudson.

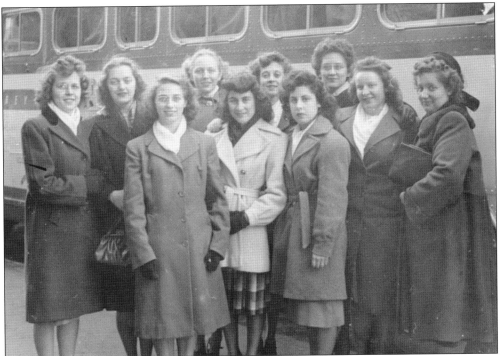

Students from the spring class of 1948 are pictured here boarding a bus to travel to Des Moines to take state board examinations. These exams were scheduled for specific dates only. Today, students continue to take this exam, but it is now known as NCLEX, and there is more flexibility with scheduling, as it is now offered in multiple cities in Iowa. (Courtesy Betty Atkins.)

Betty Atkins has signed her picture, along with Pearl Zemlicka, an examination official, who wrote a number below her signature. This approved Atkins to be admitted to sit for her State of Iowa Board of Nurse Examiners testing. Students were required to include a picture of themselves with their testing application, which would later be presented on the day of testing. Pictures were used to identify students and ensure each student took his or her own test. Some students recalled wearing their picture pinned to their shirts. (Courtesy Betty Atkins.)

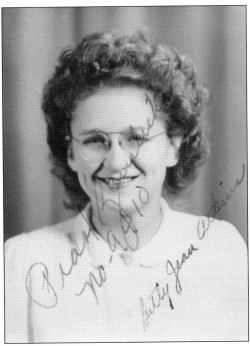

49

Betty Atkins successfully completed her state board exams and received a certificate conferring the title of Registered Nurse on April 1, 1948. The certificate indicates that it expired unless renewed by June 30 each year. This allowed Atkins to work for many years as a nurse; she spent most of those at Allen Hospital in the obstetrics department. She worked with numerous Allen students and had a tremendous impact on their education. (Courtesy Betty Atkins.)

Instructor Marianne (Brooks) Reynolds (left) presents a Florence Nightingale lamp to a graduating student in the early 1980s. The student wears a white nursing uniform and cap and carries her diploma. The change from the student uniform to a white nurses' uniform signified completion of the program.

Traditionally, a baccalaureate service was held on the morning of graduation. Readings, hymns, and a pastoral message usually given by the hospital chaplain were featured in most baccalaureate services. Pictured above is a ceremony in the late 1970s or early 1980s in the gymnasium in Dack Hall. Below, the class of 1995 is preparing for their baccalaureate service in the W.D. Oetting Chapel in the hospital. The service included a special message and singing. (Above, courtesy Barb Seible.)

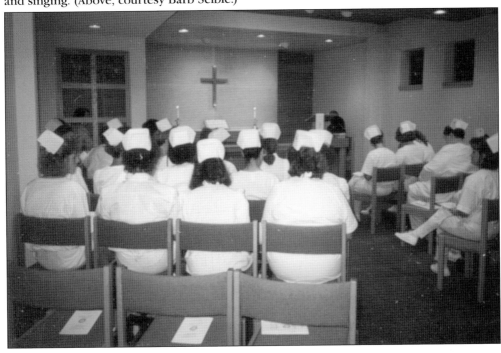

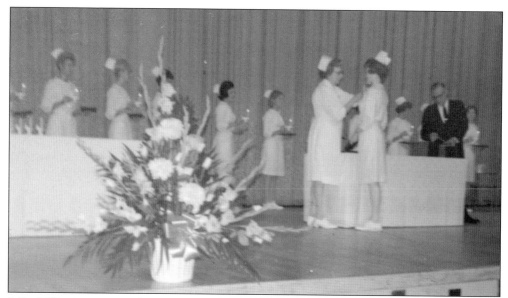

Julie Miller is receiving her pin from Virginia C. Turner, director of the diploma nursing program, during the graduation ceremony held at West High School in Waterloo in June 1967. After this, Miller continued across the stage to receive her diploma and Nightingale lamp. Nurses frequently wore their school pin on their uniform or on their name badge while at work to show they were an Allen graduate. (Courtesy Julie Simbric.)

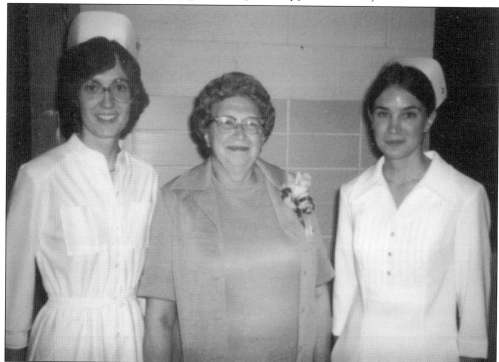

Virginia C. Turner presented countless students with their Allen pins at graduation. In this 1980 photograph, she is all smiles with graduating seniors Kathy (Perry) Loy (left) and Dana Wedeking, who are wearing their white nursing uniforms for the first time. (Courtesy Dana Wedeking.)

Kathy deNeui (center) stands with two classmates on graduation day in September 1955. After three years of classes at Allen and ISTC, clinical experiences, and residence life, graduating nurses formed a close bond that sustained them throughout their education at Allen. (Courtesy Kathy Janssen.)

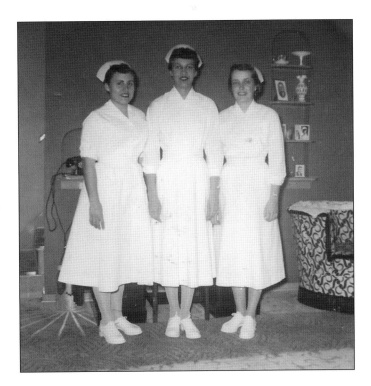

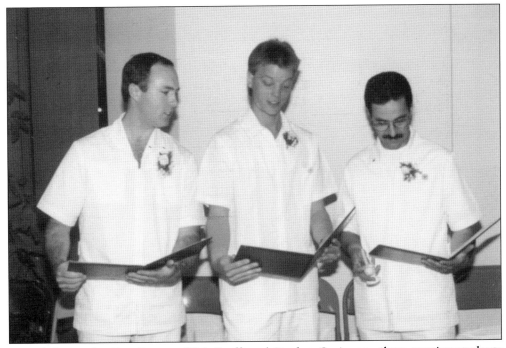

From left to right, Curt Boysen, Nick Graff, and Stephen Springer—three nursing students from the Allen Memorial Hospital School of Nursing class of 1989—compare their diplomas at graduation. Known as "The Three Amigos" in their senior class yearbook, they, like others before them, shared unique experiences as nursing students. (Courtesy Barb Seible.)

ALLEN MEMORIAL HOSPITAL

LUTHERAN SCHOOL OF NURSING

Commencement Exercises
Class of 1981

CLASS MOTTO: "We make a living by what we get but,
we make a life by what we give."

Hoover Junior High

Thursday, June 18, 1981

Diploma program student Laurie Finley's graduation announcement from 1981, pictured at left, shows the School of Nursing building at that time. The announcement also features the class motto, a tradition practiced by each diploma program class: "We make a living by what we get, but we make a life by what we give." The below photograph shows the newly graduated Finley celebrating in front of Dack Hall. (Both, courtesy Laurie Even.)

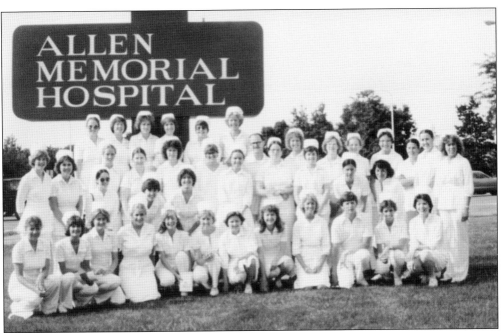

The class of 1981 is shown after attending their baccalaureate service. At the time, each class would gather in front of the Allen Hospital sign on Logan Avenue for a group picture. This tradition carried on through the 1990s. (Courtesy Laurie Even.)

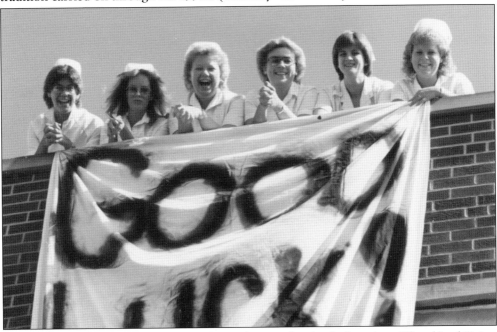

Six students from the class of 1985 celebrate their graduation by hanging a "Good Luck!" sign from the roof outside the nurses' residence. They had already attended baccalaureate service and had breakfast served to them by the faculty, a tradition for graduating seniors. Pictured from left to right are Lori Boehme, Michelle Liekweg, Angela McKenna, Marcia Benter, Patti Schwerdtfeger, and Wanda Nederhoff.

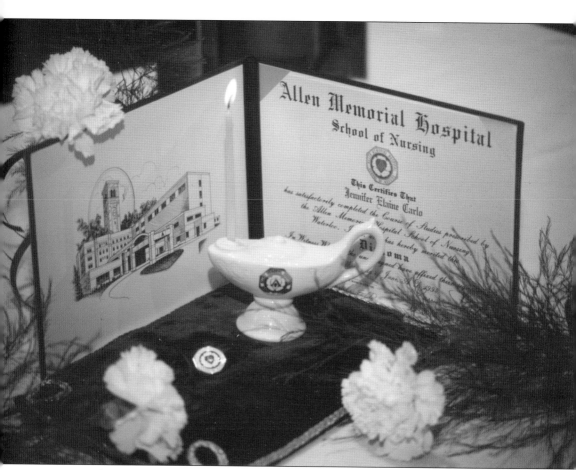

Upon graduating from the diploma program, each nurse received several items. This diploma, awarded to Jennifer Carlo in 1994, shows the hospital with the University of Northern Iowa (UNI) campanile in the back and Allen Memorial Hospital in the foreground. This signified that students received their education from attending classes at UNI and in a hospital-based diploma nursing program. A school pin with the graduate's initials engraved on the back was pinned to the student's graduation uniform during the ceremony. The lamp with a candle, a symbol of knowledge, was presented to each graduate (though in some years, students received their lamp when capped). A faculty member presented each student with a carnation as he or she left the stage. This picture shows graduation items from the Allen Memorial Hospital School of Nursing. Note that "Lutheran" is not in the name of the school on the diploma. (Courtesy Barb Seible.)

Three

RADIOGRAPHY TECHNOLOGY EDUCATION

1958–1998

In the 1950s, Allen Hospital had two certificate programs, one in radiography and the other in medical laboratory assistant/technology. Dr. Maurice Wicklund, Allen Hospital radiologist, was instrumental in beginning the 24-month program in radiologic technology when he identified the need for staff educated in radiographic procedures.

In 1958, Carol Peske Smith was the first student to enter the program, which was housed in the hospital's radiography department. A second student joined her six months later. Smith recalled memories of those early days, noting that much of their education occurred on the job with technologists and with Dr. Wicklund. Students in their second year of the program would also help teach the first-year students.

Radiologists Dr. Wicklund, Dr. John Maughan, and Dr. Oscar Lanich led the program along with radiologic technologists, including Irene Sandkamp, who directed the program for many years. Other program leaders included program graduates Janice McMullen and Gail Nielsen. Later, Doreen Towsley and Kristi Young Metcalf co-led the program. Additional faculty joined later, including Sue Robinson, Peggy Fortsch, and Christine Mattingly. Susan Trower joined as staff. They were assisted by other Radiological Services staff and administrative personnel.

In the late 1980s, the School of Medical Laboratory Assistant/Technology was discontinued due to low enrollment and the availability of a similar program at nearby Hawkeye Institute of Technology (now Hawkeye Community College).

The School of Radiology became part of the education division under vice president of education Dr. Jane Hasek. In 1996, the Allen Memorial Hospital School of Radiologic Technology transferred its hospital-based certificate program to Allen College of Nursing, later renamed Allen College. The last graduation ceremony for the certificate students took place in the spring of 1999. The Associate of Science in Radiography (ASR) program began in 1998, with the first students graduating in May 2000.

Today, the program accepts 16 students each year and prepares them for careers in hospitals, imaging facilities, physician practices, and urgent care clinics. Current leadership includes Dr. Peggy Fortsch, School of Health Sciences dean and radiography program director; Sue Robinson, clinical coordinator; and Dr. Jared Seliger, director of the Nuclear Medicine Technology Program.

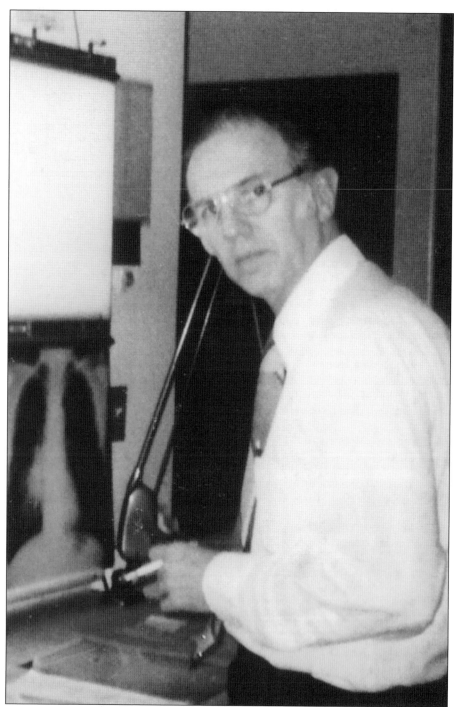

Radiologist Dr. Oscar Lanich is shown here in the 1970s reviewing a chest x-ray in a view box while standing in the Out Room. There, radiologists and students would organize films and review dictation of radiography reports. In later years, radiologists would do this in their private offices. Dr. Lanich was one of the physicians who worked closely with students in the radiography program. (Courtesy Allen Hospital Radiology Department.)

Doreen Towsley, a 1968 graduate of the radiography program, was an instructor and director of the program at Allen Hospital. In this picture from the early 1970s, she instructs a group of radiography students in a classroom in the west wing of the hospital, formerly known as the nursing home building. Classes for radiography students were held in various locations, including the hospital and School of Nursing building. (Courtesy Allen Hospital Radiology Department.)

Dr. Oscar Lanich (right) and student Kristi Young Metcalf wear lead aprons while reviewing a patient's x-ray film around 1969. Metcalf began as a student in the program, worked at Allen Hospital as a staff technologist, and later became a faculty member. (Courtesy Allen Hospital Radiology Department.)

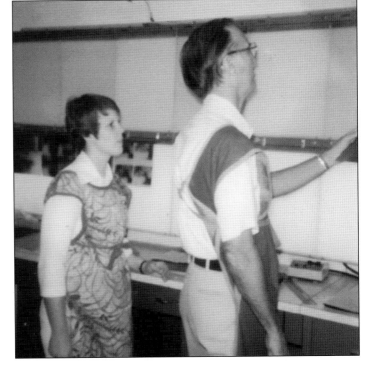

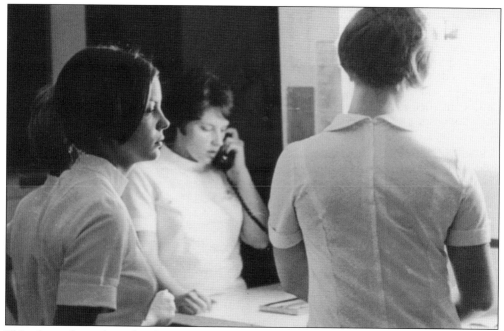

This picture from the 1960s shows the dress uniforms that were mandatory for female students in the radiography program. They also wore hose (but not white hose, as that identified nurses and nursing students), and white lace-up shoes known as "duty shoes." Around the room are signs of work being done. A small x-ray cassette rests on the table, while a phone call is coming in—possibly a call from a nurses' station or the emergency room asking for a patient's report or for a portable x-ray. (Courtesy Allen Hospital Radiology Department.)

Students of the class of 1967—from left to right, Myrna Moehling Schumacher, Gail Eikenberry Nielsen, and Wendy McGlaun Hedges—take a moment to relax. Schumacher wears the required lead apron and was likely assisting with a fluoroscopy procedure. Nielsen later served as director of radiography at Allen Hospital. (Courtesy Allen Hospital Radiology Department.)

In the early days, graduation ceremonies were simple and often involved a dinner for students, their families, instructors, and radiologists. This photograph taken at the graduation of the class of 1968 shows, from left to right, Vicky Wagner Moore, Irene Sandkamp, Dr. Maurice Wicklund, Doreen Towsley, Dr. Oscar Lanich, and Nancy Stech Stull. (Courtesy Allen Hospital Radiology Department.)

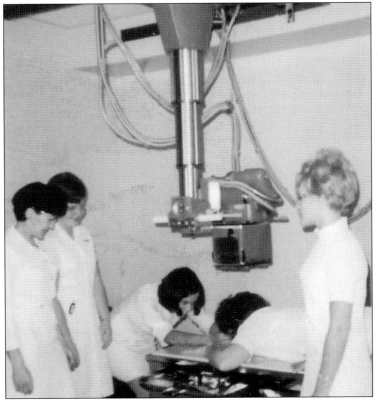

Students practiced many skills in their program, including positioning a patient on an x-ray table. Here, students practice preparing a "patient" for an x-ray of facial bones. Students could angle the x-ray tube and make the pictures smaller or bigger as needed. Pictured from left to right are Irene Sandkamp (instructor), and students of the class of 1969 Martha VanEe Drenner, Trudy Warneka Mann, unidentified (on the table), and Martha Anton Mueller. (Courtesy Allen Hospital Radiology Department.)

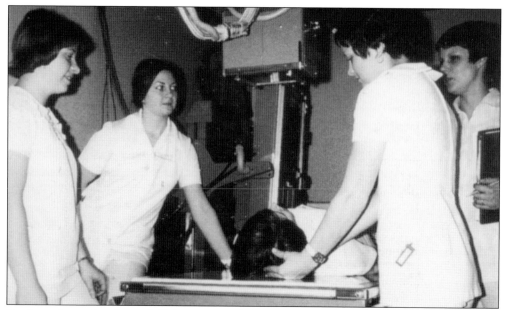

Students from the class of 1977 practice skull positions on an x-ray table. Students were tested on their abilities to position patients correctly without help and to identify what size of film should be used. From left to right are Deb Midthus, Ellen Mixdorf Morris, unidentified (on the table), Diane Millang Berger, and instructor Kris Metcalf. (Courtesy Allen Hospital Radiology Department.)

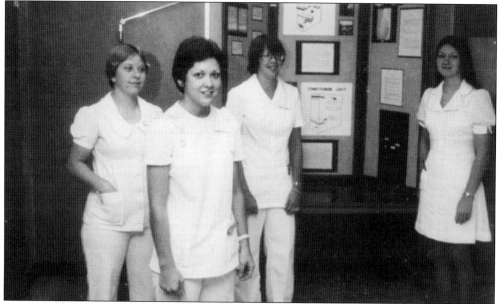

Once a year, students presented papers and posters at the North East Iowa Society of Radiology Technologists. Allen students participated along with students from other local radiography programs at St. Francis and Shoitz Hospitals in Waterloo. This mid-1970s picture shows (from left to right) students Deb Midthus, Diane Millan Berger, Marilyn Pries Silvers, and Ellen Mixdorf Morris and their poster on Xeromammography. (Courtesy Allen Hospital Radiology Department.)

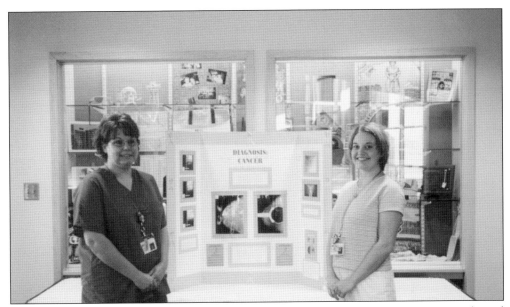

Radiography students Angela Klatt (left) and Annie Ubben are displaying a poster board presentation for National Radiologic Technology Week at Allen College on November 4–10, 2001. The focus of their poster is diagnosing cancer. They are standing in front of a display case in Barrett Forum.

After graduating from the radiography program, some students went on to work at Allen or another hospital, and some went on to become faculty members and teach at Allen. Pictured from left to right are education secretary Susan Trower; instructor Christine Mattingly; instructor Sue Robinson, Allen class of 1976; and instructor Peggy Fortsch, Allen class of 1985.

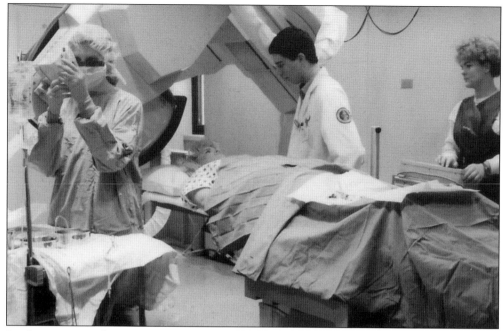

Students practiced various procedures they would encounter as radiologic technicians. Here, students from the class of 1993 perform a mock angiography procedure in the angiography suite in the hospital. The camera above the bed rotated to provide different images and views of the patient. From left to right are an unidentified staff technologist and students Regina Ogle, Amy Jo Towsley, and Tom Franzen. (Courtesy Allen Hospital Radiology Department.)

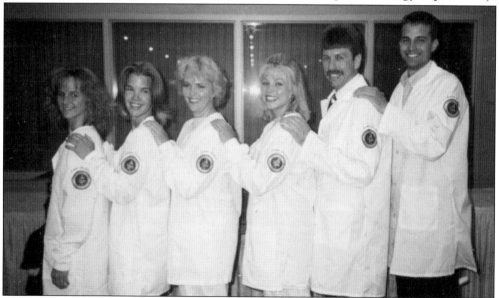

Junior radiography students line up from shortest to tallest at the graduation breakfast honoring the class of 1996. From left to right are Pam Kampman, Julie Ingersoll, Trisha Bohlen, Jan Tesdahl, Jerry Huisman, and Martin Maddux. Note the radiography certificate program insignia on the left shoulder of their lab coats. Above it is embroidered "Junior Student," which showed students' placement within the program.

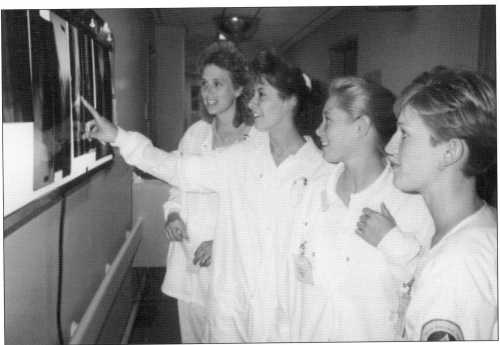

The radiography program ensured students applied radiography theory to their clinical experiences. These students from the class of 1997—from left to right, Mary Butz, Stacy Arends, Brandy Gilson, and Jodi Scott—examine x-ray images in the radiology department at the hospital. Each is wearing a name tag for identification along with a radiation badge clipped to the lab coat collar or name tag.

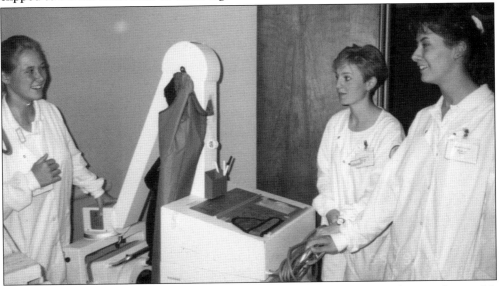

Students learned how to use the hospital's portable x-ray machines when working with patients who were unable to get to the radiology department. They could angle the arm to position it as needed and use the touch panel to input information. Students brought their lead vests with them when using the portable machine. Pictured are class of 1997 students Brandy Gilson, Jodi Scott, and Stacy Arends.

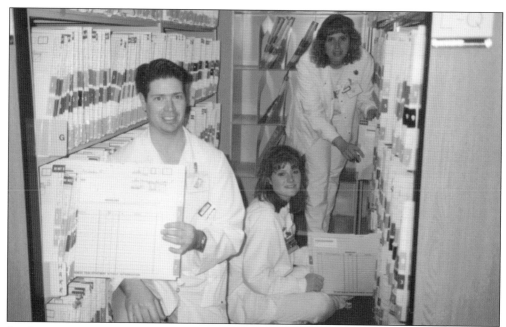

Students spent time in the film storage room in the hospital's radiology department pulling and filing various patient film jackets. Each jacket contained patients' old and new films. Some files would require multiple film jackets, and students needed to know and understand the special filing system. Today, patients' films are saved on computers. From left to right are Jerry Randall, Angie Thompson Shipp, and Mary Butz, all students from the class of 1997.

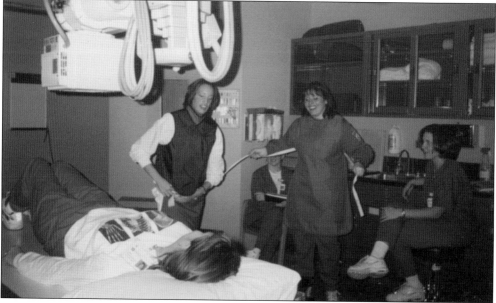

Students from the last class to graduate from the radiologic technology program in 1999 work with faculty and clinical coordinator Sue Robinson to demonstrate the proper technique for taking an x-ray. One of the first steps was to put on lead aprons to limit their exposure to radiation. From left to right are Sue Robinson (on the table), Nicole Grovo, unidentified (seated in rear), Callie Leisinger, and Dana Weber.

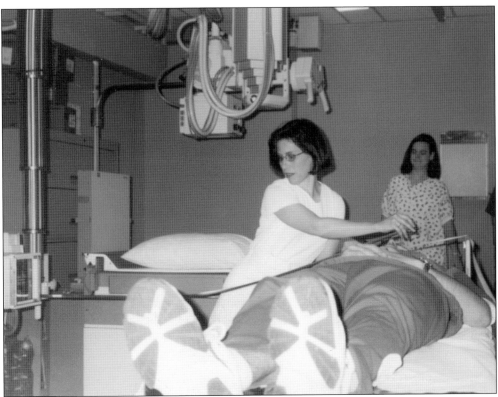

Instructor Peggy Fortsch teaches student Leslie Lyons about the correct positioning technique for an x-ray. One of the criteria students were evaluated on was their skill performance. This was done by clinical instructors in the hospital's radiology department who supervised them. As students moved through the program, the procedures became increasingly complex.

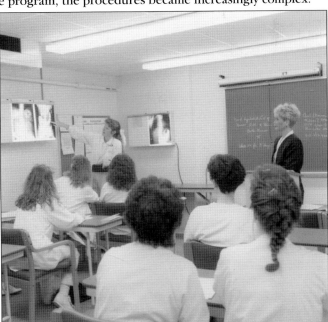

Classes for the certificate program were held in the radiology department of the hospital for many years. As the program grew, dorm rooms on the second floor of Dack Hall were converted into classroom space. Sue Robinson (left) and Doreen Towsley are shown teaching in one of these rooms in the early 1990s. (Courtesy Cole Photography.)

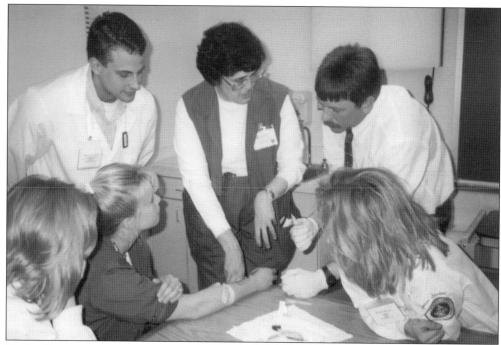

Linda (Davis) Flint, 1961 School of Nursing diploma graduate and registered nurse in the holding room at Allen Memorial Hospital, prepared patients for surgery, and as such, became an instructor of IV starts for many staff in the hospital. Here, she instructs radiography students from the class of 1996. Clockwise from lower left are Julie Ingersoll, Jan Tesdahl, Martin Maddux, Linda Flint, Jerry Huisman, and Pam Kampman.

Class of 2001 Associate of Science in Radiography (ASR) students (from left to right) Jennifer Hardman, Craig Buskohl, Alyson Colvin, Scott Musson, and Leslie Lyons have just practiced inserting intravenous (IV) needles into each other's veins. They proudly display the bandages on the back of their hands. Learning to insert an IV was an important part of their education, as they would need to use IVs to transmit medication or dye when working with patients.

Dr. Lawrence Liebscher, medical advisor for the radiologic technology program in 1996, conducted monthly educational sessions for the students that included film analysis and review of anatomy and pathology as shown in the films. He explained x-ray procedural steps and the "why" behind doing a procedure to get an optimal image. The information helped students apply their theory and knowledge to a patient's films. Class of 1997 students pictured here are, from left to right, Sarah Tellin, Mary Butz, Jerry Randall, and Angie Thompson Shipp. Dr. Liebscher is seated in front.

Radiologists Dr. Oscar Lanich (far left), Dr. Lawrence Liebscher (second from left), and Dr. Maurice Wicklund (far right) were instrumental in the education of radiologic technology students. Gail Nielsen (second from right), a program graduate, was the director of radiology and worked closely with Doreen Towsley, director of the radiologic technology education program, and faculty. (Courtesy Cole Photography.)

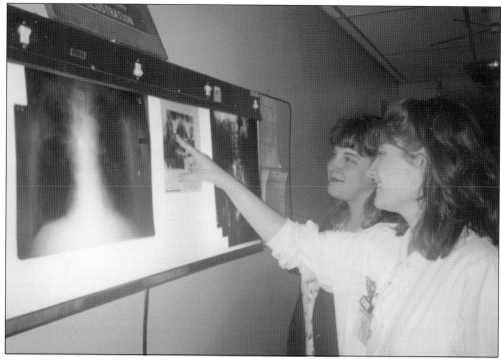

Angie Thompson Shipp (foreground) and Sarah Tellin, radiography students from the class of 1997, review a radiograph that was part of the Interesting Illustration program (as noted on the sign above the view box). This program was designed as a continuing education experience for Allen Hospital radiographers.

Class of 1995 certificate students pose for a formal graduation picture. This class is wearing burgundy robes with silver ribbons and medallions around their necks. Pictured are, from left to right, (seated) David Merry and Jason Bell; (standing) Rachel Stolfus, Donna Needham, Kari Reser, Toni Akers, and Kathy Schultz. (Courtesy Cole Photography.)

Student marshal Diana Huisman leads the procession of radiologic technology students into Nazareth Lutheran Church at the graduation ceremony in the spring of 2011. As a student who has completed one year of her education, she is wearing a royal blue robe and carries the college's Associate of Science in Radiography (ASR) banner. (Courtesy Barb Seible.)

ASR student Kelly Druvenga, followed by student Adam Dohrn, walks to the front of Nazareth Lutheran Church at the start of their graduation ceremony in 2003. After the certificate program was transferred to Allen College and became the Associate of Science in Radiography program, students attended a joint graduation ceremony with the Bachelor of Science in Nursing (BSN) students. Radiography students wore silver robes and caps signifying the awarding of an associate's degree, while nursing students wore black robes and caps signifying a bachelor's degree or higher. (Courtesy Barb Seible.)

71

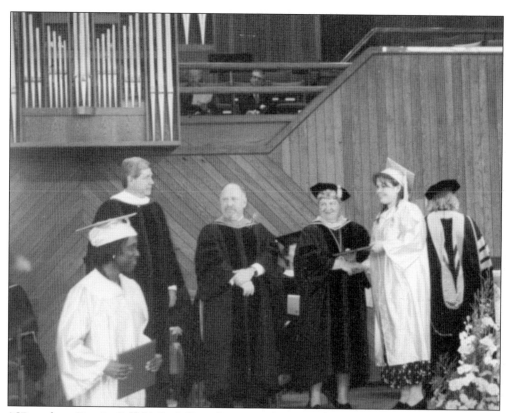

ASR students Damita Saffold (far left) and Tracy Stull (second from right) receive their diplomas from Sam Wallace, president of Iowa Health System (second from left); Rick Seidler, CEO of Allen Hospital (third from left); and Dr. Jane Hasek, chancellor of Allen College (third from right), at the graduation ceremony in May 2003. Wallace gave the graduation address and also received a doctor of humane letters honorary degree for his significant contribution to Allen College.

The graduation ceremony of spring 2003 includes graduates turning to face the audience for congratulations. From left to right, ASR students Adam Dohrn, Kim Hansen, Kelly Druvenga, and Diana Husman were seated in the front rows for the ceremony at Nazareth Lutheran Church in Cedar Falls. BSN graduates are wearing black robes and include from Brooke Adams (left) and Barbara Bixby.

Four

ALLEN COLLEGE

1989–PRESENT

In 1989, a degree-granting institution, Allen College of Nursing, was incorporated as a subsidiary of Allen Health Systems. It was later renamed Allen College. The Allen Health System Board was passionate about its support of the School of Nursing and, as a result, did not close the program until Allen College was fully developed, accredited, and had its first graduates. The last School of Nursing class was admitted in the fall of 1994, and the last students graduated and the program officially ended in 1997.

Dr. Jane Hasek navigated the monumental changes taking place with the School of Nursing and the formation of the college. She served as the first chancellor of Allen College from 1980 to 2005. Dr. Jerry Durham then assumed the chancellor position and has continued to make Allen College a premier healthcare education institution by expanding the programs and degrees offered.

The nurses' residence and Dack Hall were razed in 2007 to accommodate changes for both the nursing school and hospital. A new campus built north of the hospital provided state-of-the-art learning facilities, increased classroom space, and additional faculty and staff offices. Gerard Hall, the first of the new buildings at Allen College, was completed in 1995, followed by Barrett Forum in 2000 and Winter Hall in 2012.

The hospital continues to be an important part of students' education by offering sites for clinical experiences and providing jobs to nurses and technicians. Students also travel to different locations in the Cedar Valley for clinical experiences, including physicians' offices, River Hills School, United Medical Park, and Covenant Medical Center, now Wheaton Franciscan Healthcare.

Today, Allen College has grown to offer an associate degree in radiography and a bachelor of health sciences degree with majors in diagnostic medical sonography, nuclear medicine technology, medical laboratory science, public health, and dental hygiene. It also offers master's degrees in nursing and occupational therapy and two doctoral degrees in health professions education and nursing practice.

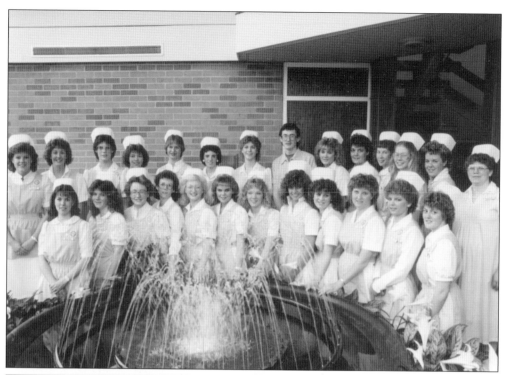

Many Allen graduation ceremonies have been held at Nazareth Lutheran Church in Cedar Falls. Here, the last class to graduate from the diploma program gathers around the church's fountain for one final picture in 1997. In keeping with tradition, Allen College continues to hold graduation ceremonies for all its programs at the church. (Courtesy Jane Hasek.)

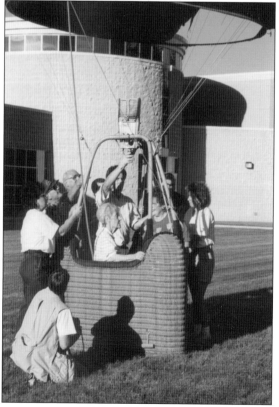

May (Wendt) Flemming entered as a student nurse in the first class in 1925. Later, she became an instructor in the program. One of her lifelong dreams was to ride in a hot air balloon. This dream was fulfilled on the Allen College campus in 1997. She attended the alumni banquet celebration with the last class to graduate from the diploma program. She passed away in 2000. (Courtesy Jane Hasek.)

Dack Hall (above) and the School of Nursing (below) looked different in the 1990s than they had a few decades before. Dack Hall's colorful hand-fired ceramic murals that told the story of the school and its association with the hospital were covered and no longer visible. They had been located beneath the two peaks of the front building, centered between the large sets of windows. The student dormitory also looked different. Its characteristic peaked roof was changed during a remodel of the fourth floor. The inside of the school also changed along with the needs of the program and its students. (Both, courtesy Barb Seible.)

When students entered the School of Nursing using the Dale Street entrance, they immediately saw the front desk in Dack Hall where the housemother (and later the receptionist) sat. To the left of the desk was this staircase leading to the students' rooms. In later years, when fewer students lived in the residence, some of these rooms became faculty offices and classrooms. Throughout the history of the residence and school, many student pictures were taken on these stairs. (Courtesy Barb Seible.)

This corridor in the original School of Nursing contained the computer lab and faculty offices; farther down was classroom 136. At left is the hallway leading to the C.W. Seibert Library, named in honor of the longtime Allen physician and instructor. The hall also contained classrooms, the nursing skills lab, and the administrative office and secretary, which were also accessible from a stairway in the dormitory. (Courtesy Barb Seible.)

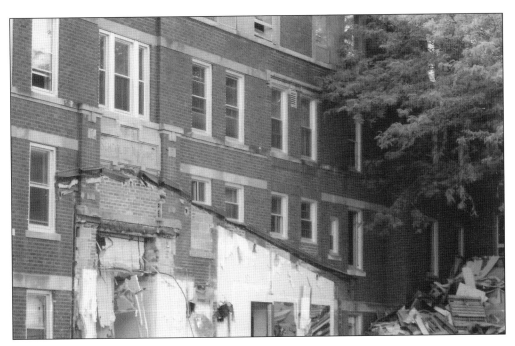

Progress requires change, and in 2007, the Allen School of Nursing (the original entrance pictured above) and the nurses' residence and Dack Hall (below) were torn down to create room for the expansion of the hospital and its services. (Above, courtesy Barb Seible; below, courtesy Madeline Wood.)

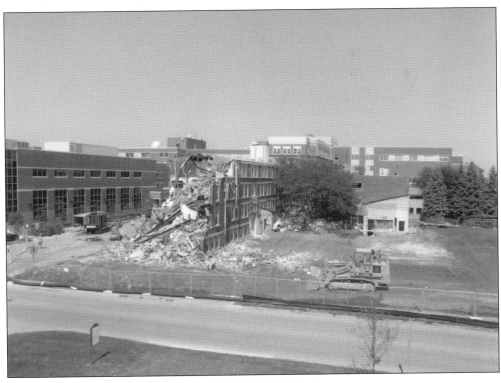

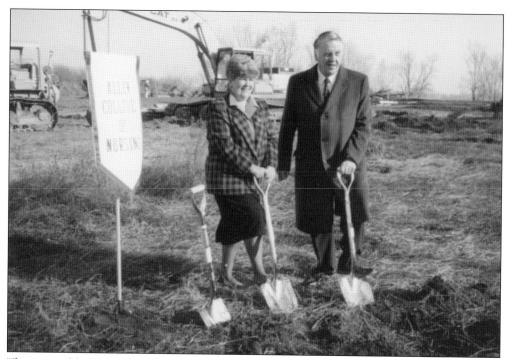

The ground-breaking ceremony for the Health Education Center on the Russell S. Gerard II campus took place on November 17, 1993. Pictured above are Dr. Jane Hasek, the first chancellor of the college, and Larry Pugh, CEO of Allen Memorial Hospital. Below, Dr. Russell S. Gerard II, Allen physician, ceremoniously lifts a shovel of dirt for the building named in his honor. (Both, courtesy Jane Hasek.)

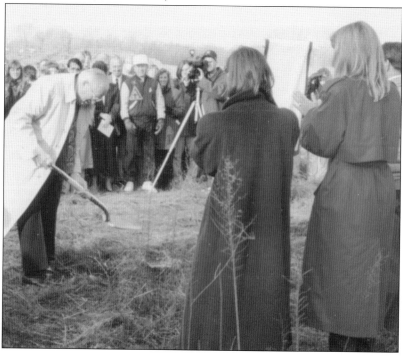

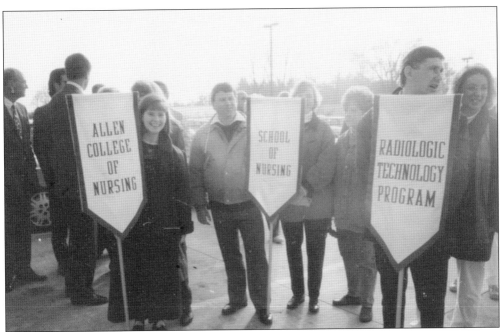

At the Gerard Hall ground-breaking ceremony, three students hold signs representing the different programs at the college. Tami Swift holds the sign for Allen College of Nursing, Pat Mahoney holds the one representing the School of Nursing, and Gary Soldwich holds the sign for the Radiologic Technology Program.

Gerard Hall opened to faculty and students in April 1995. On the day of the grand opening, the entire building was wrapped in a blue ribbon. Classes in the diploma program continued in the original School of Nursing building until the last diploma program class graduated in 1997.

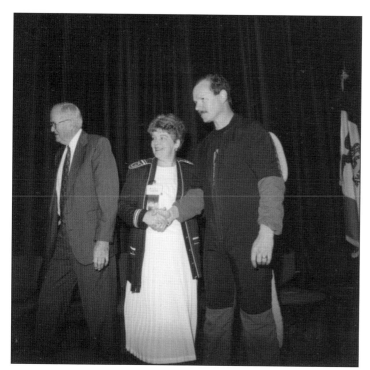

Dr. John Musgrave (far right), Allen Hospital physician, is still in his parachute suit as he joins Dr. Russell S. Gerard II (left) and Dr. Jane Hasek in the auditorium for the Gerard Hall grand opening. Dr. Musgrave had just landed outside the building to mark the beginning of classes on the new Health Education campus. (Courtesy Cole Photography.)

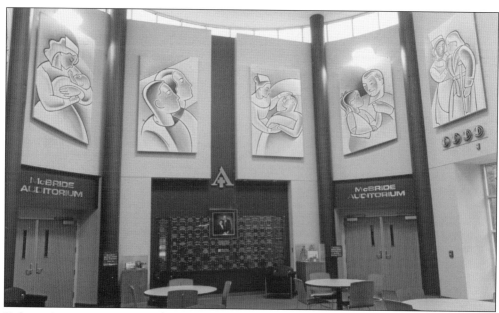

Helman Associates Inc. designed these murals hanging in the rotunda of Gerard Hall. Each mural is six feet tall and depicts the history of education at Allen College with images of nursing, radiography, and the medical laboratory program. The collection is designed to show the caring spirit and commitment of healthcare professionals. (Courtesy Barb Seible.)

McBride Auditorium, located inside Gerard Hall, was named in honor of Michael and Virginia (Henniges) McBride. Virginia was a student at Allen in the early 1960s when she was in a car accident. With the support of Virginia C. Turner, director of the School of Nursing, she was able to continue her studies and graduate from the Allen Memorial Hospital Lutheran School of Nursing in 1962. Pictured are Virginia McBride (left) and Virginia Turner in front of the auditorium bearing McBride's name. (Courtesy Cole Photography.)

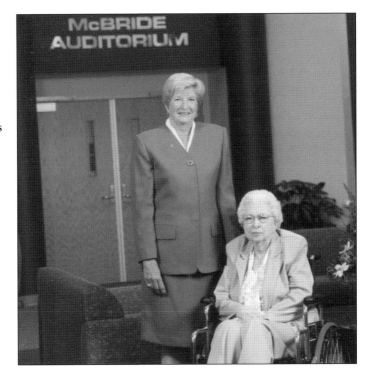

On May 3, 1997, faculty who had taught in the diploma program were invited back for a special reunion as the School of Nursing was closing. Pictured are some of those who attended, including, from left to right, (first row) Sharon Graber, Marcia Hillman, and Dr. Jane Hasek; (second row) Jo O'Connor, Susan Junaid, Vicki Barth, Marianne Reynolds, and Sandi Thurm. This celebration was held in the new Gerard Hall.

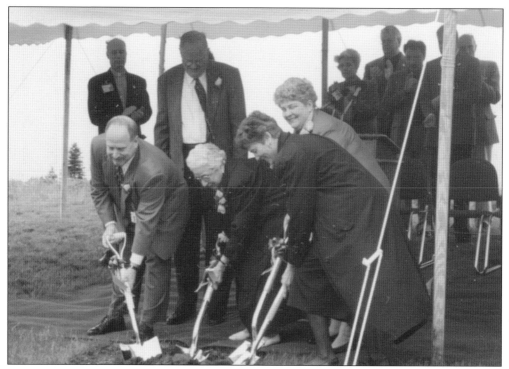

Barrett Forum was the second building on the new campus. Its ground-breaking ceremony was held on May 7, 1999. From left to right are Rick Seidler, CEO of Allen Health Systems; Pauline Barrett; Dr. Jane Hasek; and Fran Mueller, who served on the Allen Hospital Board of Directors and the Allen School of Nursing advisory committee and as an Allen College trustee. Behind them is Dr. Russell S. Gerard II. (Courtesy Barb Seible.)

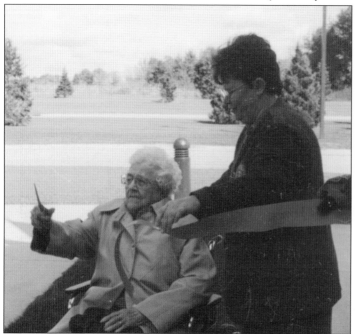

The official ribbon-cutting ceremony for the opening of Barrett Forum took place on October 6, 2000. That day, Lucille (Tubesing) Carolan, a 1945 graduate of Allen Memorial Hospital Lutheran School of Nursing and a longtime instructor, did the honors with JoAn Headington, an Allen graduate from the class of 1966, by her side. (Courtesy Barb Seible.)

This grand piano was a gift to Allen College by Dr. John Glascock and his wife, Dorothy. Dr. Glascock was an anesthesiologist at Allen Hospital from 1963 to 1988. His patient teaching manner was extended to the many diploma program students who rotated to the obstetrics and surgery departments. The piano is located in the Barrett Forum, where it can be enjoyed by students and staff alike. It is not uncommon to find Allen students playing it after busy days of classes and clinicals. It is also played for many college events.

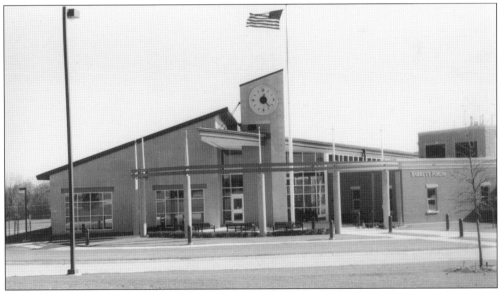

The Chancellor's Tower is part of Barrett Forum, the second building constructed on the Health Education Campus. Virginia (Henniges) McBride and her husband, Michael McBride, donated funds for the tower and requested that it be called the Chancellor's Tower to honor Dr. Jane Hasek, the first chancellor of Allen College.

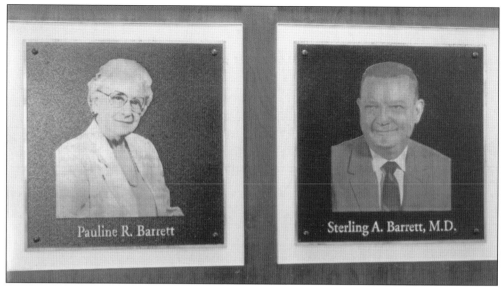

Barrett Forum was named for Pauline R. and Dr. Sterling A. Barrett. They are pictured on the donor wall inside the building. Dr. Barrett was an ophthalmologist in Cedar Valley for many years. Pauline Barrett donated money to the college in his honor. (Courtesy Barb Seible.)

The Allen College campus was designed in the prairie style and meant to flow with the natural landscape using horizontal lines and very little decoration. This bronze sculpture by Jane DeDecker, titled "Who's Looking at Who," rests on special stone selected from Stone City, Iowa. Located on the patio behind Barrett Forum, it shows children, a squirrel, and a turtle all looking at each other. The sculpture was donated by Ann Enderlein in memory of her father, Dr. F. Harold Reuling, an ophthalmologist at Allen Hospital. (Courtesy Barb Seible.)

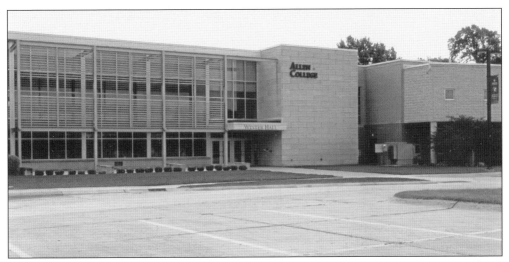

Winter Hall, which joins Gerard Hall and Barrett Forum, opened in 2012 and allows students to move freely between the three buildings. Winter Hall houses two large and two medium-sized classrooms along with faculty and staff offices. The two large classrooms on the ground floor have a collapsible wall that can be opened or closed to change the size of the room depending on need. The west-facing windows on the outside of the building highlight the casual gathering space inside the entryway. Carlton and Thelma Winters' generous donation greatly helped support the fundraising effort for the building. The Winters owned and operated Ben Franklin stores in Waterloo from 1959 to 1981.

Allen College graduated its first class in 1994, and the new diploma cover reflected the changes at the school. The left inside cover shows Gerard Hall, the first building on the new campus. The new pin, designed for the BSN program, is displayed along with the medallion worn by the first chancellor of the college, Dr. Jane Hasek, at graduation ceremonies. (Courtesy Barb Seible.)

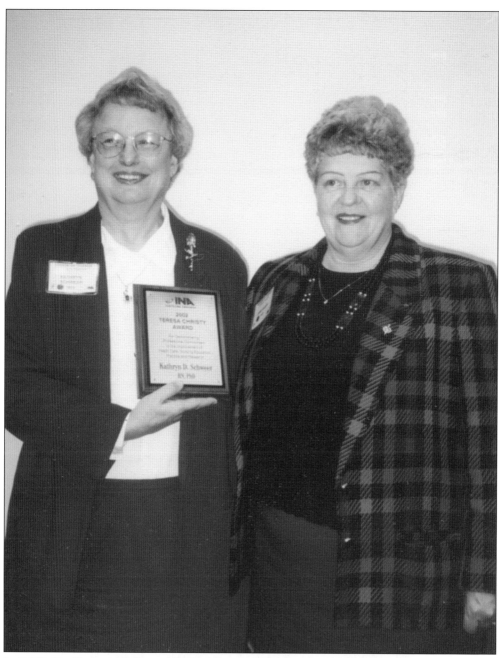

In 2002, Dr. Kathryn Schweer (left), Allen College dean of Academic Affairs, received the Teresa E. Christy Award. She is pictured here with Dr. Jane Hasek, who received the same award in 1997. This award was established in 1982 and is presented to a registered nurse who has demonstrated professional commitment to the improvement of healthcare and the interrelationship of nursing education, nursing practice, and nursing research. This is the highest award given by the Iowa Nurses Association (INA). Individuals are nominated by their peers and recognized for their commitment to nursing. Dr. Hasek served on the Iowa Board of Nursing from 2004 to 2013 and was chair for the last three years. (Courtesy Jane Hasek.)

The medallion and chain of office worn by the chancellor at graduation ceremonies symbolize the history and tradition of Allen College. The medallion shows the college seal, while the chain of office names the college's degrees, core values, and chancellors. The mace, which is made of walnut, banded with brass rings, and bears the Allen College seal, is carried by a faculty member who leads the commencement procession. The mace was designed and handmade by Wayne Hasek (pictured at right below), husband of Dr. Jane Hasek (pictured above and at left below), and was presented to the college in 2005. The chancellor's medallion, chain of office, and mace were gifts to Allen College from the Hasek family given in memory of Dr. Jane Hasek's parents, Margaret and Harold Blecher. (Both, courtesy Jane Hasek.)

Dr. Jerry Durham has served as chancellor of Allen College since the fall of 2005. Since then, Allen College has continued to grow in size and programs. The college now offers undergraduate degrees in dental hygiene, public health, a medical laboratory science program, nuclear medicine technology, diagnostic medical sonography, Associate of Science in Radiography, accelerated Bachelor of Science in Nursing programs, a master of science degree in nursing and in occupational therapy, and doctor of education and doctor of nurse practitioner degrees. A doctoral degree in physical therapy is being planned.

Students in a leadership course finalize the day's clinical by recording notes taken while working with a staff RN and faculty member. In this course, students learn to organize care for a group of patients, make assignments, follow up on concerns, and make rounds with physicians. From left to right are class of 1995 students Sara Thomson, Sheena Franzen, unidentified, and Tami Westhoff.

BSN student Michelle Gerdes, class of 1997, delivers a tray to a patient at meal time. Her next duties will include assisting the patient with washing hands and sitting up in bed. She will also set up the tray to be accessible for the patient and will also check for any eating restrictions the patient may have, including special diet considerations.

Students in the BSN program continued to take part in clinical rotations to the obstetrical and pediatric wards. Stephanie Nelson, BSN class of 1998, wears scrub clothing and shoe covers to maintain a clean environment as she wheels a baby from the nursery to its mother. Nelson is assigned a mother and baby and will assist both; her duties might include assisting with breastfeeding, baby's bath and umbilical cord care, and the mother's recovery needs.

Darlene Shipp (right), obstetrics faculty, and BSN student Alisha Engle are on a mission to deliver this baby from the hospital nursery to her mother for feeding time. Engle went on to become an assistant professor at Allen College. Shipp, a 1965 Allen graduate, retired from teaching at Allen College in 2015.

Faculty member Roberta Standafer (left) watches over Tara Helgeson, a 1996 BSN graduate, as Helgeson completes her charting. A typical rotation would include eight students per faculty member. This made for a busy day, with each student assigned to a patient to assist with baths, ambulation, eating, treatments, passing medications, and charting.

Sara Beschan (left) and Tina Hage, BSN class of 2003, practice bandaging wrists. However, if this were a sterile procedure, Beschan would need to wear sterile gloves. Students learned multiple dressing techniques in class and from their textbooks. Afterward, a faculty member would be nearby to guide students in how to carry out the proper procedures.

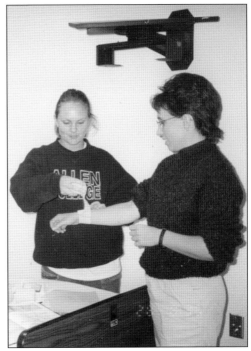

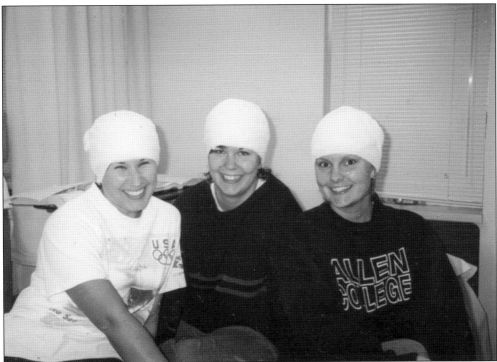

"Just wrapping things up" could be the title of this bandaging lab for students in the BSN program. From left to right, Kelly Howard, Amada Palas, and Sara Beschan, all from the class of 2003, proudly show off their bandaging skills. Beschan also displays school pride with her Allen College sweatshirt.

Rochelle Ohde (left) and Sarah Ulses, Allen College BSN students, are all smiles as they have clinical together at Allen Hospital. They have prepared for their day by wearing the required name badges and their stethoscopes for the many health assessments they will complete. They both graduated from the BSN program in 2000.

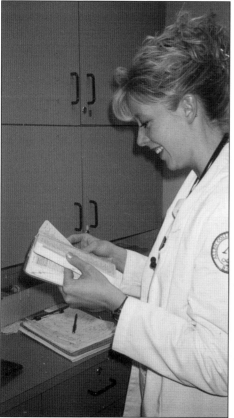

Annette Geary, Allen College BSN class of 2000, looks up information about medicine her patient will receive. She is paying special attention to the five "rights" of medication administration: right patient, right dose, right medication, right route, and right time. As a student nurse, she must know the reason the patient is taking the medication, any incompatibilities with other medications the patient takes, usual dosage, side effects, and any teaching/instruction she must give the patient about the medication.

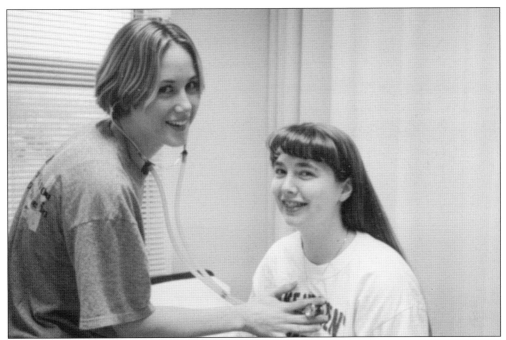

Students Bridget Frey (left) and Amy James, class of 2004, have learned about heart and lung sounds in their Health Assessment class. Here, Frey practices her skills by listening to James's heart and lungs. These skills were learned early in the students' BSN program and were utilized throughout their clinical experiences.

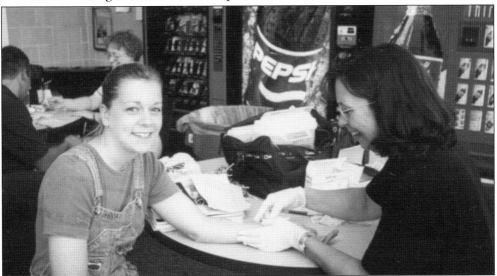

Stephanie Swanson (left), BSN class of 2004, receives her tuberculosis skin test during Fall Fling in 2001 from Anne Doeden, a 1976 School of Nursing diploma graduate and occupational health nurse at Allen Hospital. TB testing was done annually to ensure students remained healthy while caring for patients. Fall Fling, held on the first day of classes, provided opportunities for students to meet requirements including receiving immunizations and getting their ID pictures taken. They could also sign up for extracurricular activities like yearbook, Nurses Christian Fellowship, and Allen Student Nurses Association (ASNA).

NU445I, Perioperative Nursing, was an elective course in the BSN curriculum. It gave students an opportunity to explore a specialty area of nursing. From left to right, Michaela Haughland, Ashley Beck, and Kallie Moeller stand in front of the operating room schedule board during class in 2011. This magnetic board replaced the old chalkboard system. An electronic board later replaced both of these systems. (Courtesy Barb Seible.)

Barb Seible, Perioperative Nursing instructor, meets with a small group from her spring 2011 class. Students completed four different assignments: circulating, scrubbing, ambulatory surgery, and post anesthesia care unit. Seible directs students to specific observations of RN responsibilities such as induction of anesthesia, positioning, prepping, and safety of patients and staff. Pictured are, from left to right, Seible, Kelly Barnett, Kelly Tokheim, Katie Rettey, and Audrey Salow. Tokheim holds a paperwork assignment that she will complete later that day. (Courtesy Barb Seible.)

Students completing their Bachelor of Health Sciences degree can do so with an emphasis in Medical Laboratory Science (MLS). This and the Nuclear Medical Science (NMS) program were implemented in 2009. Pictured here are students from the 2009–2010 MLS program class. From left to right are (first row) unidentified, Brenda Barnes (instructor), and Shawn Froelich; (second row) Val Johnson, Kevin Ramsden-Meier, Melissa Schmidt, and Kate (Halliwel) Weller.

At left, MLS students practice making hematology slides in a classroom on the Allen College campus. From left to right are Darcy Dochterman, Lissa Mohon, and Jorge Rivera. Below is Kari Neverman, 2015–2016 MLS student.

Michaela Haughland graduated from the BSN program in 2012 and returned to get her MSN degree in 2016. She is pictured wearing her master's hood at the 2016 graduation. The velvet underside of the hood is apricot, signifying nursing, and the royal blue lining represents Allen College. (Courtesy Barb Seible.)

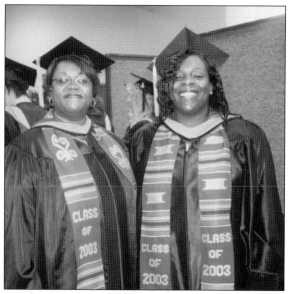

Pam Young (left) and Robin Meeks wore their personally-designed stoles at their graduation in spring of 2003. Young designed hers to include the Greek symbols for wisdom and learning, and Meeks's included the Greek symbol for wisdom. Both women were graduates of the MSN program.

"Serving to learn and learning to serve" is a brief but powerful definition of service learning at Allen College. Students actively participate in community partnerships with the goal of developing civic responsibility and commitment to their communities. Mary Brown, faculty member, was instrumental in developing service learning in the Allen College curriculum. The Center for Engagement, Learning and Leadership (CELL) was dedicated to Anne Christensen Doyle on March 27, 2013. Doyle worked at Allen College as the international admissions counselor and lost her life to breast cancer. Her family, friends, and colleagues gifted the center in her memory to teach and inspire students about philanthropy and service.

The Allen College service committee organizes service learning days for students across campus. Here, students serve the greater Waterloo community by learning about programs at the Northeast Iowa Food Bank. From left to right are an unidentified food bank staff member, Courtney Watts, Amanda Thornburg, Cindy Jenness (instructor), Shae Robinson, and Katura Retty.

In 1999, the NU 245A Mission Nursing in Jamaica class found nursing conditions very different from what they had experienced in the United States, where supplies and medicines are readily available. Pictured here are, from left to right, (first row) Brooklyn Hageman, Jacque Leutzinger (instructor), and Amy Puchta; (second row) Sarah Brouwer, Heather Koshatka, Sara Weber, and Jill Lindstrom.

Five

FACULTY AND STUDENT LIFE

1925–PRESENT

While studying and attending class took up much of their time, students also had fun. Doctors' dances, basketball games, and variety shows were common activities in the 1950s. Students also participated in the Allen Chorus, worked on the *Hi-Lites Newsletter*, and gathered to play cards or pop popcorn and watch television in one of the lounges. Students were required to live in the nurses' residence until the late 1960s, when they could be married and live off campus. From the 1950s to 1990s, the residence and Dack Hall were popular gathering sites for students who formed relationships that remained with them long after graduation.

Housemothers were an essential part of residence hall life—they made sure students signed out when leaving the school and signed back in when returning. Visitors waited in the Dack Hall lounge while the housemother called student rooms using the intercom system. The housemothers also performed nightly checks to enforce the mandatory study hours. They later walked the halls to see if students had gone to bed after lights out, although some students got around this by studying in their closets with flashlights. Today, Allen College is a non-residential campus. Students live off campus or in residence halls at the University of Northern Iowa and Wartburg College.

Faculty and staff have been and continue to be integral to students' daily life and add to the familial atmosphere at Allen. Beyond classroom and clinical experiences, faculty have participated in various social activities, including the Allen Chorus, Fall Fling, 100-day parties, Nurses Christian Fellowship, and the Pi Kappa chapter of Sigma Theta Tau, the nursing honor society.

Each year, alumni reunions connect students long after graduation and honor specific classes, especially those graduating 25 and 50 years ago. Many alumni return to tour the hospital, visit with classmates, and reminisce about the "good old days." Some continue to meet regularly, having remained in each other's lives for many years after leaving Allen—a testament to the important role the school and college played in their lives.

The nurses' residence was home to hundreds of students over the years. This letterhead from the 1960s is from stationery students could use to write letters home to family. The image shows how the School of Nursing and the hospital looked at the time. The nurses' residence and Dack Hall are on the left, the hospital is on the right, and the nursing home is toward the back. Logan Avenue is at lower left. (Courtesy Mary Ann Howe.)

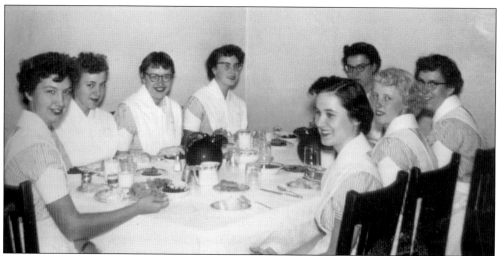

In the early days, part of students' education included learning manners and etiquette. A napkin ring was once listed among students' required items to bring with them to school. Verona Orth, a 1959 graduate, remembered sitting at a table and eating with her classmates every day. Each student knew where to sit, because she left her napkin and napkin ring at her place. (Courtesy Judith Eilers.)

This third-floor dorm room in the original building belonged to Connie Peters during her freshman year in 1963. Her room faced east and had two large windows and two single beds, although freshmen did not have roommates. She recalls bringing her own bedspread, while linens and towels were furnished and laundered by the hospital. Rooms contained a desk, dresser, and closet. Some rooms had a sink, but students shared toilets, tubs, and showers down the hall. Because the building did not have air conditioning, some students brought a fan with them. Each room had a phone that connected to the front desk, but the regular telephone was in the hall and shared by students. (Both, courtesy Connie Miller.)

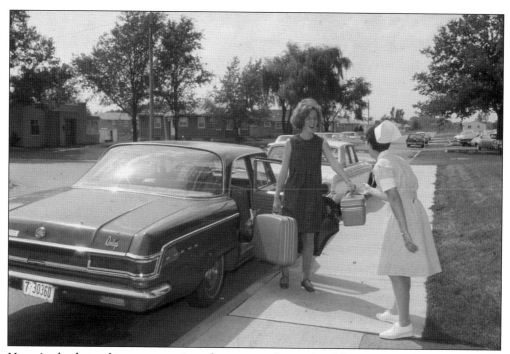

Move-in day brought many emotions for new students; thankfully, their big sisters were on hand to greet and welcome them to Allen. In addition to answering questions and "showing them the ropes," big sisters also sometimes capped their little sisters at ceremonies during freshman year. Many alumni remember their experiences with big and little sisters as a special part of their time at Allen.

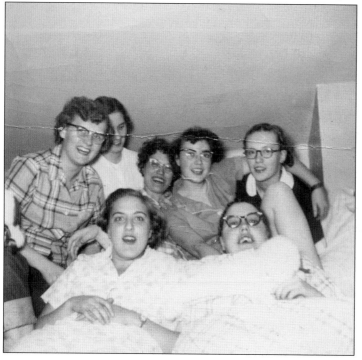

Dormitory parties, like this one from the 1950s, were regular events in the lives of students. In this party, labeled on the back of the photograph as a "diet party," provisions included fudge and cookies. Students enjoyed much-needed socialization and a break from studying as they got ready for a long evening's preparation for class and clinicals. (Courtesy Jean Stoakes.)

During their clinical rotation in pediatrics, students were assigned their own rooms in the residence hall at Cook County Hospital in Chicago. Here, several managed to squeeze into one person's room. When this happened, the only places to sit were on the bed or on the floor. From left to right are Edith Heuer Oltmann, Alice Joy Hoppe Steigerwald, Joanne Meier, Velda Devries Pitsenbarger, Hazel Steiber Copenhaver, and Jane Tegtmeye Wood. (Courtesy Edith Oltmann.)

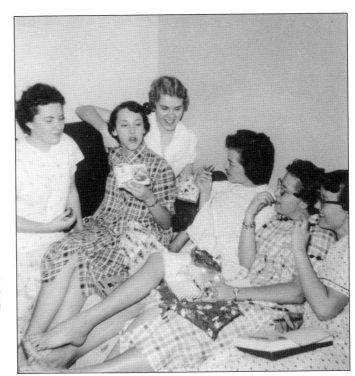

Dack Hall provided space for physical and social activities. The building included a kitchenette, classrooms, and a gymnasium. The auditorium-gymnasium was often used for ceremonies such as capping and baccalaureate, dances, and craft and bake sales. The lounge had a piano and fireplace and served as a place to study and visit with guests. Dack Hall was an important part of the School of Nursing until it was torn down in 2008.

The lounge in Dack Hall also served as a waiting area for male guests who were restricted from the student dorm rooms. Students could wait in the lounge for their guests, or guests would wait in the lounge while the housemother called the students down from their dorm rooms. Allen student Rosalie Mattke captioned the 1959 photograph at left, "Oran and Dave waiting for Joni and I (as usual)." Below, class of 1967 student Julie Miller poses with her boyfriend, Mike Simbric, in front of the fireplace in the Dack Hall lounge in November 1964. (Left, courtesy Rosalie Richardson; below, courtesy Julie Simbric.)

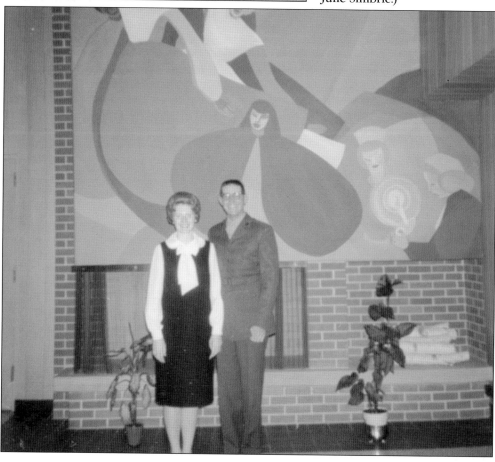

In Dack Hall, a kitchenette in the lounge area provided space for students to prepare snacks, relax, visit, and study together. These students are pictured in May 1965 enjoying pizza, soda, and conversation in the lounge. From left to right are Barbara Bramblett, Sherry McChesney, Marcia Brandt, Sheryl Torkelson, Renee Schmidt, and Milly McCollum. (Courtesy Mary Ann Howe.)

Housemothers sorted mail and placed important letters in students' individual mailboxes in the Dack Hall lounge. Students were assigned a mailbox and a combination. Checking mail became a part of students' routines, following classes and clinicals, and was considered a highlight of the day. (Courtesy Barb Seible.)

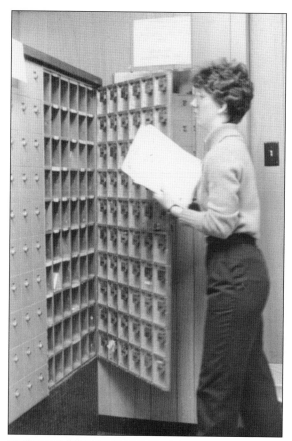

At left, a student services assistant opens the large door revealing the inside of the student mailboxes. Inside are many small openings with students' names attached. Once all mail was delivered, the door would close, and students could access their boxes by entering a combination. Students regularly joked about the difficulty of getting their combinations to work and their mailboxes to open. The photograph below was featured in the 1983 yearbook and included the caption, "For no matter how long it takes or how many to pull, I shall open my mailbox, won't I??? ...please!"

After Dack Hall opened in 1958, a housemother sat at the desk at the Dale Street entrance. She was there from 8:00 a.m. until approximately midnight on weekends, depending on the students' curfew. On weeknights, she might be there until 10:00 or 11:00 p.m. Students were required to sign in and out when leaving and returning to campus. Eva Cook was a housemother during the 1960s, 1970s, and 1980s. Housemothers used the intercom system at the desk to buzz students in their rooms to alert them to a message or a visitor. (Courtesy Laurie Even.)

While living in the residence with the students, housemothers had many duties, including answering the phone, giving messages to students, enforcing mandatory study hours, and checking on ill students. Madelyn Melchert was a housemother from the late 1940s until the early 1960s. A longtime presence at Allen, she is remembered as having cared a great deal for "her girls." Her brother, Rev. G.E. Melchert, served on the Allen School of Nursing Board of Directors. (Courtesy Verona Zelle.)

Behind the housemother's desk was the door leading to the kitchenette and students' mailboxes. The current graduating class picture hung on the wall behind the housemother's desk. Pictured here is Ruth Schultz, who worked as a housemother during the 1960s, 1970s, and 1980s. To her right is the call box used to contact students in their rooms. (Courtesy Laurie Even.)

Support staff served critical roles at the school and were regularly on hand to assist students in a variety of ways. Arlene Riggert was one of the librarians in the Allen School of Nursing diploma program library, which was located in the hallway of the Dack Hall addition.

After the era of housemothers, the gymnasium in Dack Hall became part of the Wellness Center. Evelyn Burke served as the receptionist and sat at the front desk in the 1980s and 1990s. She greeted everyone who entered Dack Hall from the Dale Street entrance and worked with nursing students who lived in the dorms.

Rhonda Gilbert has served as administrative secretary since 1992. She was the administrative assistant for Dr. Jane Hasek during the diploma program and when the school became Allen College. Later, her office was located in Gerard Hall, as pictured here, until Barrett Forum was completed and the administrative offices were moved there.

Lois Hagedorn retired on June 1, 2004, after 22 years as student services assistant at Allen School of Nursing and Allen College. Students were always appreciative of her big smile and warm reception. She welcomed students from their first inquiry and provided answers to many student questions. She was also helpful to faculty and staff. She collected data and prepared reports concerning student admissions, promotions, and graduation rates for the Admissions, Promotion, and Graduation Committees.

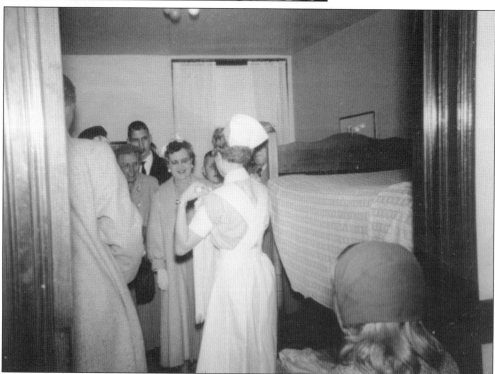

In this picture from the late 1950s, families attend the capping ceremony for a young nurse at the Allen Memorial Hospital Lutheran School of Nursing. On this evening only, students' families—even males—could visit the students' dormitory rooms. This would provide them with their only glimpse into the student nurse's college home, since only nursing students were allowed in the living areas. (Courtesy Joan Wellman.)

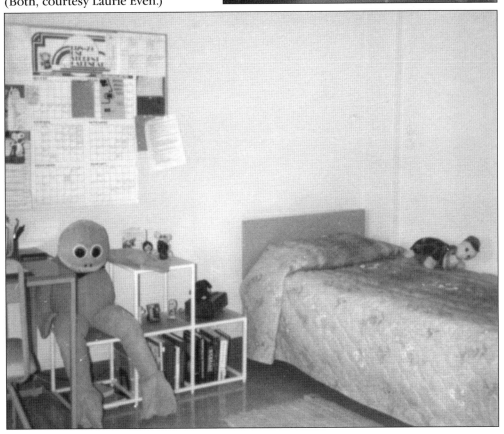

Students decorated their residence hall rooms to reflect their personalities and style. This room from the early 1980s reveals simple furniture with some personal elements to make it feel like home. The school provided a desk with a study lamp, a bed, and a bulletin board. Students were allowed to bring other items as desired, such as their own bedding and decorations. (Both, courtesy Laurie Even.)

Living spaces evolved to meet the changing needs of the students. An addition to the School of Nursing in 1962 provided rooms for two students that included built-in desks, dressers, a make-up counter, and built-in storage units. The beds could be pushed in during the day to provide seating space. The pegboard on the wall provided space to hang items and included storage shelves. Each floor contained 11 of these double rooms. This room from the 1980s, which was part of the 1962 addition, shows more modern conveniences such as a telephone, television, and stereo.

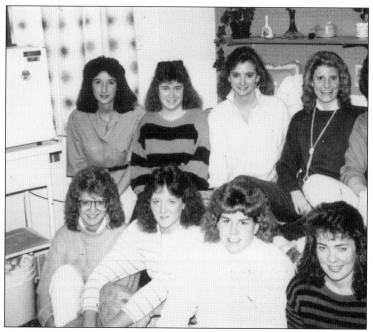

This third-floor dorm room in the newer east/west wing of the residence hall, built at the same time as Dack Hall, served as a gathering place for this group of students from the classes of 1989 and 1990. From left to right are (first row) Laura Spoerre, Tracy Mathers, Kimberly Meirick, and Dee Ann Kueker; (second row) Nancy Bourke, Christine Hall, Jennie Dalluge, and Tamberly Bleeker.

Students spent a lot of time away from their families during the holidays while in school. In the late 1950s, a Christmas tree in one of the lounges in the nurses' residence was set up and decorated by the students. Sharing the holidays with their new "family" of nursing students became a special occasion. The tradition continued through the 1980s, as shown in the picture below of students decorating the tree in front of the fireplace in Dack Hall. Note that the mural by Jessie Loomis is no longer visible. (Right, courtesy Joan Wellman; below, courtesy Jane Hasek.)

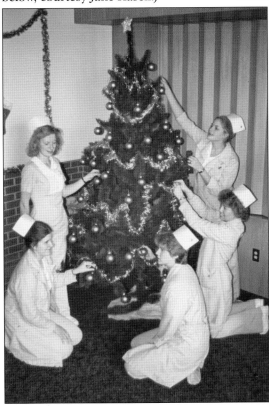

Christmas programs helped unite students as they celebrated the holidays at school. One such program included the story of the birth of Christ. In this 1950s photograph, nursing students pose as the "three wise women" bringing gifts to the baby Jesus in his cradle. (Courtesy Kathy Janssen.)

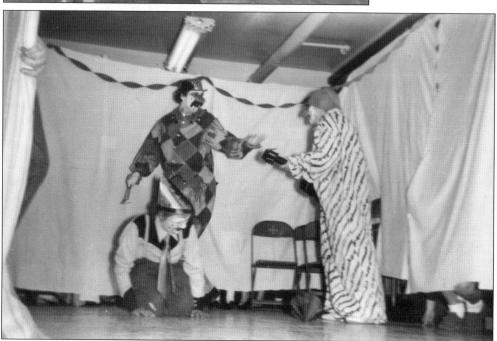

Student variety shows and parties were popular among students in the diploma program. These gave students a much-needed break from busy days of attending classes and working in the hospital during clinicals. This mid-1950s variety show featured students dressed as clowns. (Courtesy Madeline Wood.)

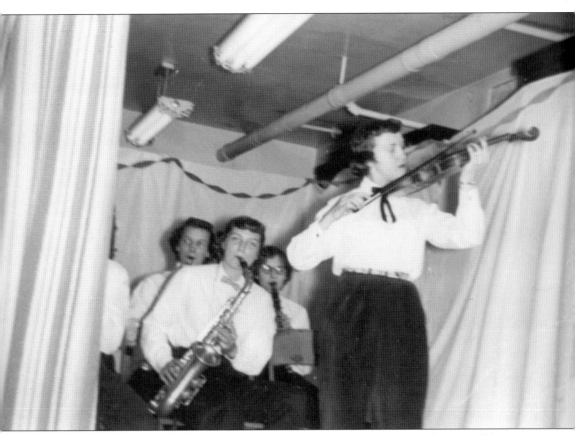

In this mid-1950s variety show, students are playing musical instruments for one of the acts or possibly during an intermission. The variety show gave students a chance to show off their many talents apart from nursing. (Courtesy Madeline Wood.)

A student-run carnival in the late 1950s drew a large crowd that attended and took part in the different booths. This carnival took place in the Dack Hall gymnasium. (Courtesy Rosalie Richardson).

In 1966, students participated in a variety show titled "This Land is Your Land" in the Dack Hall gymnasium. Students put on skits and sang and danced to music. They were also responsible for managing lighting, creating the set, and providing music. This picture shows students performing during their opening number, "Another Opening, Another Show," from the musical *Kiss Me Kate*. (Courtesy Julie Simbric.)

Student variety shows continued into the 1970s. This photograph shows four girls wearing green costumes with black bow ties in a skit called "Grasshoppers" from the show "I Believe In . . ." (Courtesy Janice Fitkin.)

119

Basketball was a recreational activity available to students in the 1950s and 1960s. Pictured at left is student Janet Timmons, class of 1962, dressed in her Allen team uniform. The back of the uniform read "Allen Nurses" and included the player's number. The 1959 team, coached by Dick Frey, finished with seven wins and one loss. According to the yearbook, the highlight was the team's win over Marshalltown with a final score of 45–44. (Courtesy Janet Larson.)

Students Mary Jackson and Renee Fangman face their classmates as they share a laugh while studying in the lounge in the late 1970s or early 1980s.

The kitchenette in Dack Hall looked different in the late 1970s as opposed to how it appeared in the 1950s and 1960s. One of the walls featured a mural designed by the class of 1976. They painted a rainbow in the background and then added smaller pictures of experiences and memories from their nursing education, such as the one pictured here.

This metal sculpture hung above the fireplace in Dack Hall from the early 1980s until Dack Hall was torn down in 2007. Donations for this sculpture were gifts from the Allen Memorial Hospital Lutheran School of Nursing class of 1981 to the Dr. Ivan Powers memorial fund. The sculpture was commissioned in the spring of 1982, and the artist was Rick Poldberg of Garrison, Iowa. The sculpture symbolizes commitment, caring, and growth, and included the school pin. It is now located on the wall in the McKinstry Student Center near the doorway of the administrative offices in Barrett Forum. (Courtesy Barb Seible.)

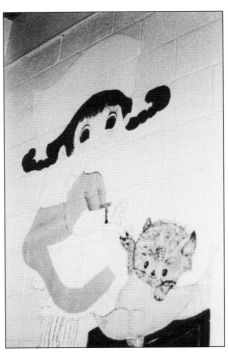

During the 1992–1993 academic year in the diploma program, student Amy Fisher was the recipient of the Virginia C. Turner Scholarship. This picture shows Fisher receiving the scholarship plaque from Turner. Through her years as an educator and administrator and long after her retirement, Turner, a generous supporter of nursing education, was known as a no-nonsense and tough but kind presence at Allen; she passed away in 1999.

Students and staff spent an afternoon baking Christmas cookies together in 2001. They shared them with the student body and also delivered them to Allen College donors. Pictured from left to right are Anna Lemmenes, Wendy Arp, Brooke Adams, Lois Hagedorn and Joanna Ramsden-Meier (from student services), and student Becca Mellman.

Because of the school's small size and the bonds formed during students' shared time living in the residence hall, those at Allen formed a close-knit community, and faculty and staff took part in many activities together. Here, Lucille Carolan enjoys a laugh with an unidentified student at graduation. (Courtesy Nancy Lamos.)

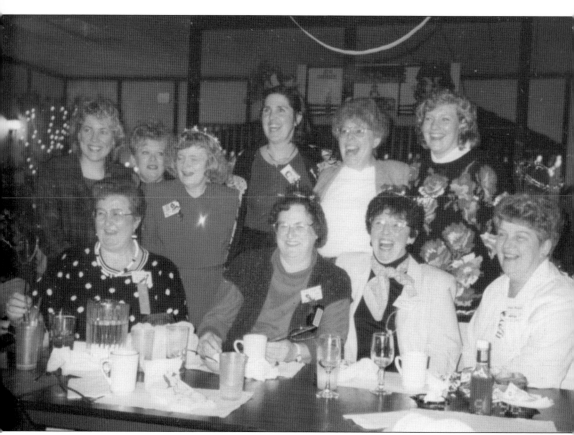

Diploma nursing students in the 1980s and 1990s had a tradition of recognizing their achievements by celebrating with "half-way" and "100-day" parties; the latter referred to the 100 days left until graduation. These parties marked milestones for students in their education. Here, diploma program faculty and staff celebrate with students from the class of 1996 at their 100-day party. From left to right are (first row) Darlene Shipp, Barb Seible, Marianne Reynolds, and Jane Hasek; (second row) Marcia Hillman, Susan Trower, Glenda Sidler, Kathy Merry, Sharon Graber, and Jen Dilacher. (Courtesy Barb Seible.)

Many Allen School of Nursing graduates can say that Ellen Patten (left) and/or Darlene Shipp (right) served as their obstetrics instructor. Patten began teaching at the Allen Memorial Hospital Lutheran School of Nursing in 1960 and retired in the early 1990s. She and Shipp were an OB instructing team from 1975, when Shipp joined the faculty, until Patten's retirement. Patten was a soft-spoken, caring instructor who was very respected by students. Shipp graduated from the Allen School of Nursing in 1965 and worked primarily in obstetric nursing until she joined the faculty. She had a caring, professional manner and was dedicated to OB nursing. Students dedicated the 1985 yearbook to Patten and the 1989 yearbook to Shipp. Below, Patten (background) is on clinical teaching Kim Price (left) and Pam Bisbey, class of 1986 students, about the care of a baby in the neonatal intensive care unit at St. Francis Hospital (later known as Covenant Medical Center).

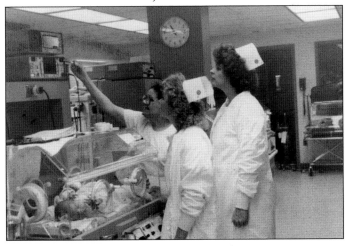

Former and then-current faculty of the Allen Memorial Hospital Lutheran School of Nursing came together for this picture in Gerard Hall during the alumni reunion in 1997. Pictured are, from left to right, (first row) Sandi Thurm, Jan Donlea Erpelding, Mary Brown, Glenda Sidler, Barb Seible, and Marcia Hillman; (second row) Sally Blitsch Kelly, Jacque Leutzinger, Barbara Braband, Doris Butler, Jo O'Connor, Marianne Reynolds, Elizabeth Dinsdale, Darlene Shipp, Nancy Muntzing, Vickie Barth, Sharon Graber, Susan Junaid, Deb Van Mill, Diane Young, and Jane Hasek. (Courtesy Vanderwerf/Fratzke Photography.)

Many alumni return each year for the alumni banquet, where classes are honored based on having graduated five, ten, twenty years ago, and more. Pictured here are alumni from the class of 1955 at their 50th reunion in 2005. From left to right are (first row) Avis Bachman Johnson, Shirley Janssen Spain, and Helen Lubs Hubert; (second row) Kathy deNeui Janssen, Madeline Armstrong Wood, Nancy Hansen Thiele, Fran Kaus Shrunk, and Jackie Thompson Black; (third row) LaMae Jessen Hamblin, Rosalie Jaacks Kadavy, and Caryl Stockdale Nielsen. (Courtesy Madeline Wood.)

Dr. Jane Hasek worked with JoAn Headington, chair of the Allen Alumni Association and its board members, to establish the Allen College Alumni Hall of Fame. Inductees are recognized for their dedication to nursing and healthcare education at Allen. The first distinguished alumni honored in 1997 was May Wendt Fleming (pictured), one of the original graduates from the class of 1928. Others inducted into the Hall of Fame include Darlene Shipp (1998), JoAn Headington (1999), Virginia Turner (2000), Sadie Holm (2000), Delores Carter (2001), Anita Zander (2001), Darlene Sickert (2002), Doris Guy (2003), Linda A. Robinson (2005), Dr. Jane Hasek (2006), Irene Moody (2007), Dr. Lee Nauss (2008), Betty Wexter (2008), Virginia McBridge (2012), Mary Marienau (2013), Barb Seible (2015), Mavis T'Slaa (2016), and Connie Miller (2016).

The history of nursing education at Allen Memorial Hospital is depicted in this afghan. Barb Seible, a 1970 Allen diploma program graduate and longtime faculty member, designed it to preserve the history of the School of Nursing and depict the future of education at Allen College. It shows each of the school's pins from 1925 to 1997—three for the diploma program, and one for the College of Nursing that began in 1989. It also includes images of the nurses' residence, the hospital, Dack Hall, familiar artwork and murals, the School of Nursing, and the first building on the new campus. The center shows Darlene Jansen, class of 1958, being capped by her big sister, an image that also appeared in the class yearbook with the phrase, "She enters nursing." Sales of the afghan continue to support students' education through the Afghan Scholarship at Allen College.

DISCOVER THOUSANDS OF LOCAL HISTORY BOOKS FEATURING MILLIONS OF VINTAGE IMAGES

Arcadia Publishing, the leading local history publisher in the United States, is committed to making history accessible and meaningful through publishing books that celebrate and preserve the heritage of America's people and places.

Find more books like this at
www.arcadiapublishing.com

Search for your hometown history, your old stomping grounds, and even your favorite sports team.